A–Z
OF
WORTHING

PLACES - PEOPLE - HISTORY

Kevin Newman

AMBERLEY

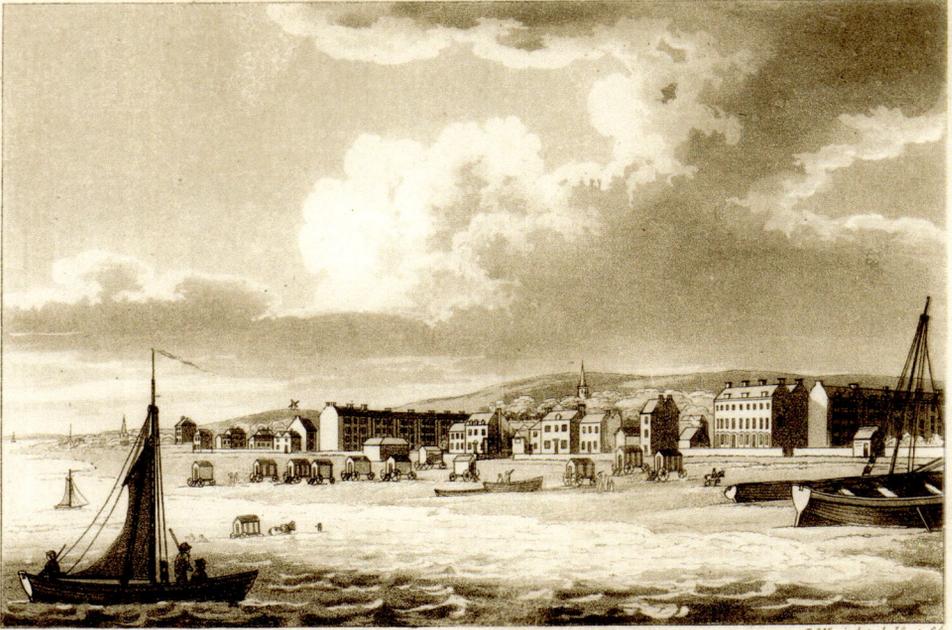

The seafront at Worthing, *c.* 1820. (Courtesy of West Sussex Past Pictures, West Sussex County Library Service)

First published 2024

Amberley Publishing
The Hill, Stroud, Gloucestershire, GL5 4EP
www.amberley-books.com

ISBN 978 1 3981 0444 0 (print)
ISBN 978 1 3981 0445 7 (ebook)

British Library Cataloguing in Publication Data. A catalogue record for this book is available from the British Library.

Typesetting by SJmagic DESIGN SERVICES, India. Printed in Great Britain.

Contents

Introduction

I am delighted to be able to follow D. Robert Elleray's wonderful *Millennium Encyclopaedia of Worthing* with a light-hearted, alphabetical look at wonderful Worthing, possibly Britain's most underrated seaside town. *A–Z of Worthing* has no pretensions of being anywhere near as detailed or comprehensive as Elleray's work, but is, I hope, a look at the unusual, interesting and quirky sides of the town and its good (and not so good) folk from days gone by.

I grew up in Brighton, but my family rarely went to the beach there; instead, we drove 11 miles to Worthing. Over the years I have discovered I'm not alone, which made me realise that this makes Worthing something special. If Brightonians, with their world-famous beach, chose Worthing, and most of the rest of the population visiting the south coast choose Brighton, then this perhaps suggests it is a different class of place – the place for those in the know. Even today, living just north of Worthing's Downs, I still prefer the wide sandy beaches of Worthing (at least at low tide) to those of my birth town. That might be why Worthing, not Brighton, is deliberately my nearest seafront town.

Worthing's architecture may not be as grand as that of its easterly elder neighbour, nor can it match Brighton and Hove's 1,218 listed buildings, but the town has a charm all of its own. It has far more of a family feel, a gorgeous pier and, best of all, no busy dual carriageway separating the town from its beach. At Worthing you can sit on the pebbles at Coast Café without the roaring A259 above you. Venture east of CrabShack and the only transport you encounter for a while is people-powered, and the view of Brighton across the bay from Worthing is preferable to the view of Worthing from Brighton. It is also far easier to get onto and enjoy the beach in Worthing; you can park right next to it and then walk straight on it. Brighton seems slightly separate from the sea, whereas the

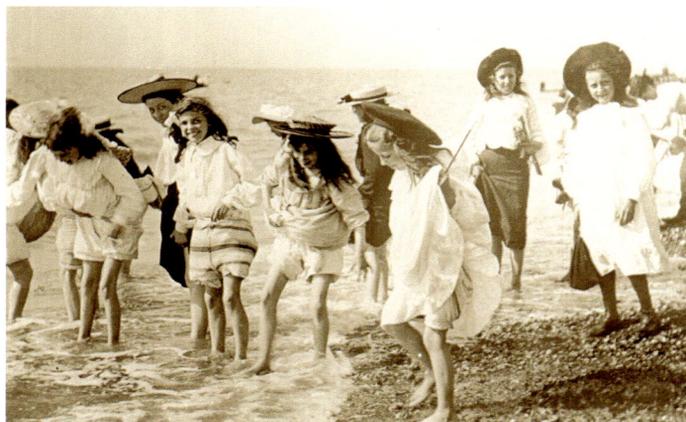

Happy children paddling on Worthing Beach, *c.* 1900. (Courtesy of West Sussex Past Pictures, West Sussex County Library Service)

Worthing Beach, home of various watersports past and present.

sea seems closer to the people of Worthing. Even the town's most famous first visitor, Princess Amelia, daughter of George III, came here as the higher 'cliffs' of Brighton would have made her journey to bathe while suffering from knee pain somewhat trickier.

Today Worthing isn't just a place for the ill and the elderly, and is no longer deserving of the nickname it once held – 'God's Waiting Room'. While it remains a restful retirement place, it is also a place for families and Brighton expats like myself, and those seeking a decent garden without eye-watering property prices. It has a wealth of culture, decent family-owned eateries and drinking dens, and an increasing focus on outdoor living, from beach volleyball to extreme watersports. Not many towns can boast that one of their residents has jumped over its pier, as well as having competitors throwing themselves off it for charity. Nowhere I have found has had both Jane Austen and Oscar Wilde stay among its residents.

Of course, Worthing still has its share of issues, problems and difficulties that all coastal resorts face. Its past has been chequered too: it had a dark dalliance with the Far Right in the early 1930s, electing the first Far Right councillor and local fascist leader, as well as hosting several fascist events. Anti-Semitism reared its ugly head even as young Jewish refugees were being protected from Hitler's onslaught and genocide. Equally, though, Worthingites can be proud that the town seems to have been the first place whose people fought back against fascists, two years before the infamous 'Battle of Cable Street' in London's East End. Much civic pride should also be generated by the role locals played in welcoming wartime refugees from Spain and Nazi Germany. We entertained a famous African American actor and singer here at a time of great racial hatred in America and gave refuge to Abyssinian Emperor Haile Selassie when Mussolini's forces invaded his country. He rather liked our pier, and who can blame him?

Worthing has not only fewer listed buildings than Brighton, but it has lost a far higher proportion of its architecturally valuable buildings than its neighbour, including the town

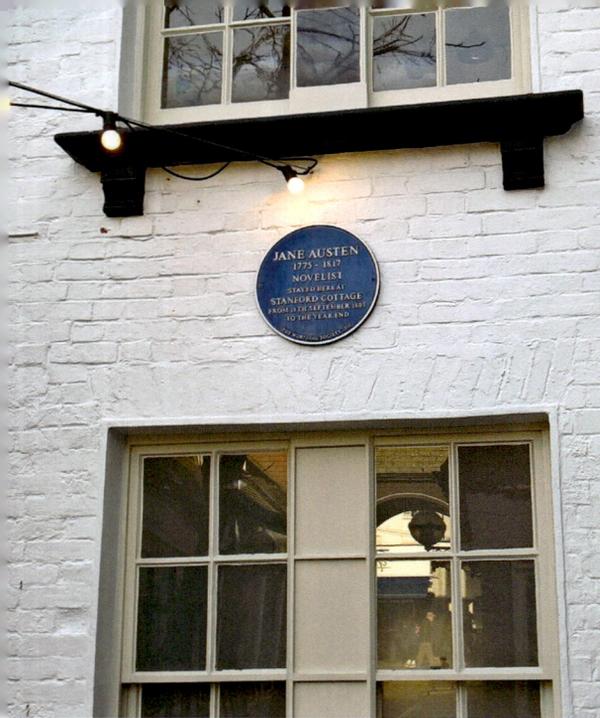

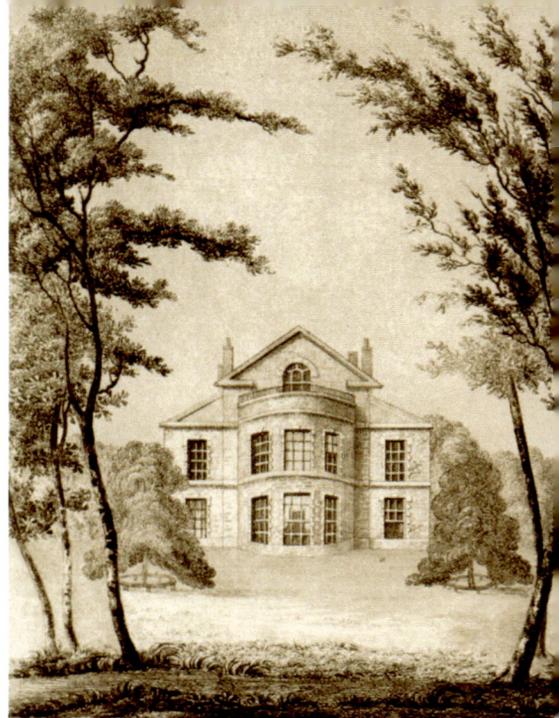

Above left: The plaque on Stanford's Cottage, celebrating that this house was temporarily home to the Austen family – at the end of 1805 and possibly into 1806.

Above right: Warwick House and gardens, sadly demolished 1896. (Courtesy of West Sussex Past Pictures, West Sussex County Library Service)

centre's eighteenth-century Warwick House and grounds in 1896. Worthing also lost much of the town's heart in the late 1960s and early 1970s when streets such as Market Street and Cooks Row were demolished to create the unpopular (and rarely fully occupied) Guildbourne Centre. Demolition of valued Victoriana continued even into the 1980s. So, how to atone for this? The area covered by the Stagecoach bus depot could be replaced with a development maximising the use of a prime seafront location and perhaps pay homage to the genius that was Jane Austen, who lived just north of the depot in Stanford's Cottage (it would have had a view down to the sea in its early days). If the council recreated Worthing's historic High Street (partly demolished to extend the dual carriageway by what is now Waitrose to the Steyne, and then left as car parks) it could have a charming shopping street, drawing shoppers across the whole town centre. It is also tragic that the busy transport artery that is the A27 is squeezed into a capillary through the north of the town and Oscar Wilde's place of stay is now a car wash, garage and block of flats. But never mind.

Architects may not find as much to admire in Worthing as in its cheekier big brother, but it perhaps means the few buildings of merit that survive are treasured more. The Dome, Beach House, Field Place, Castle Goring, Bedford Row, Warwick Road and Steyne Row still show the best of the town. And, hey, at least in Worthing you are able to find a whole beach to yourself at times – even in the summer. Worthing is almost a well-kept secret, and I am almost thankful more Brighton visitors fail to 'go west' (as the Pet Shop Boys sang).

Above: Bedford Row recently.

Right: Stagecoach offices, with the bus depot behind. Could this prime Worthing site become a centre to celebrate Austen or Wilde?

In just my adult lifetime, Worthing has gone from something of a joke to somewhere people are passionate about and want to move to, especially after the lockdowns of Covid-19. The first time I think I ever really contemplated Worthing as something other than the place we went to for the beach was at my Brighton Sixth Form College Revue where a pal and I were performing a low-quality version of 'Bohemian Rhapsody'. The band performing before us poked fun at Worthing by changing the lyrics of the Troggs' hit 'Wild Thing' to 'Worthing', safe in the knowledge that Brighton was superior. Fast forward to 1998, and TV writer Simon Nye was still making mirth at Worthing's expense when Martin Clunes' Gary Strang in *Men Behaving Badly* was asked if he was going to Acapulco or the Seychelles for his management conference and, he defensively replied, 'somewhere a bit special ... Worthing', resulting in laughs from Tony, Deborah and Dorothy.

Today, though, Worthing has become a serious choice of destination from those leaving London, Brighton or elsewhere. Working from home remains 'the new normal' for many post-Covid, and makes living in London far less attractive. After all, why not work where you have South Downs, sea and sand in walking distance?

Worthing is much bigger than you'd think too, situated on a wide coastal plain. When you include the suburbs of Offington, Durrington, Goring, Ferring, Findon Valley and the sprawl of East and West Worthing, you have a town of five railway stations – Goring, Durrington, West and East Worthing and Worthing main. Brighton (without Hove) also has five – the main station, Preston Park, London Road, Moulsecoombe and Falmer – yet it is double the size of Worthing, or triple if Hove is added. With a population of over 104,000, Worthing is larger than some UK cities, and vies with Crawley to be West Sussex's largest town. Worthing is certainly the second-largest settlement in the Greater Brighton coastal conurbation, and a major partner in the

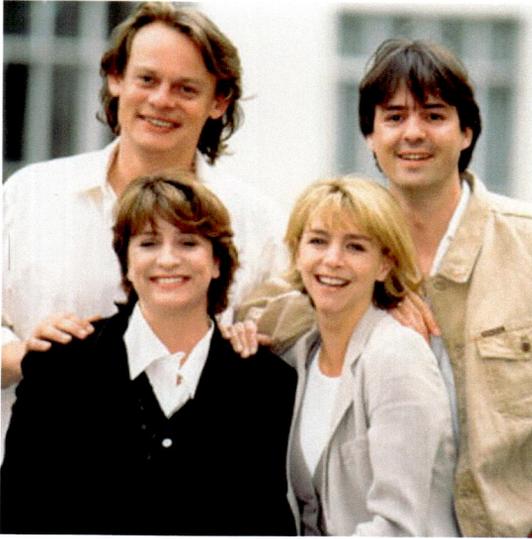

The cast of *Men Behaving Badly* back in 1998 when the series filmed in the town. (Courtesy of Simon Nye/ Hartswood Films)

Greater Brighton Metropolitan College. This all suggests that Brighton depends on Worthing for its staff, facilities and support.

All in all, I quite like the relationship Worthing has with Brighton. In some ways they are the Lennon and McCartney of the south coast. Brighton is the more acerbic, hard-living and creative Lennon, with Worthing the gentler, ballad-writing-era McCartney, but both serve to push each other forward. The rivalry between the two has indeed existed, but tends to be good-natured.

Perhaps, now that the Birdman has stopped, Worthing needs more events and quirky features so it doesn't just become another part of Greater Brighton. I loved Lewis Crathern's kitesurfing jump over the pier and think we need far more water-themed events. Perhaps more aerial events too since it was part of the location of the 1946 and 1953 world airspeed record. Or as an early site for the budding film industry (1896), Worthing's Town Hall could celebrate the fact it looks so much like the one in Hollywood's *Back to the Future*. Each year there could be a recreation in Chapel Road of Marty McFly's famous journey up to 88 mph. Imagine a starting line of soapbox imitation DeLorean cars, contestants dressed as the Doc and Marty, all trying to touch a metal 'wire' across the road – perhaps at 8.8 mph rather than 88 mph. Back to the Future Day could be our Cheese Rolling Day or Running of the Bulls. Whatever major event we embrace next, Worthing should do more to capitalise on its individuality – its separate literary, smuggling and, of course, fishing heritage. The future is as bright as a springtime Worthing sunrise or as warm as the sunset over the pier from Splash Point (recently voted one of the best views in the world).

So, whether you intend to dip in and out, or travel this A–Z of Worthing as a whole, I hope you enjoy this peek into the past and present of Sussex's underrated gem. As my fellow entrants to my Sixth Form Revue sang: 'Wor-thing. You make my heart sing. You make everything ... groovy.'

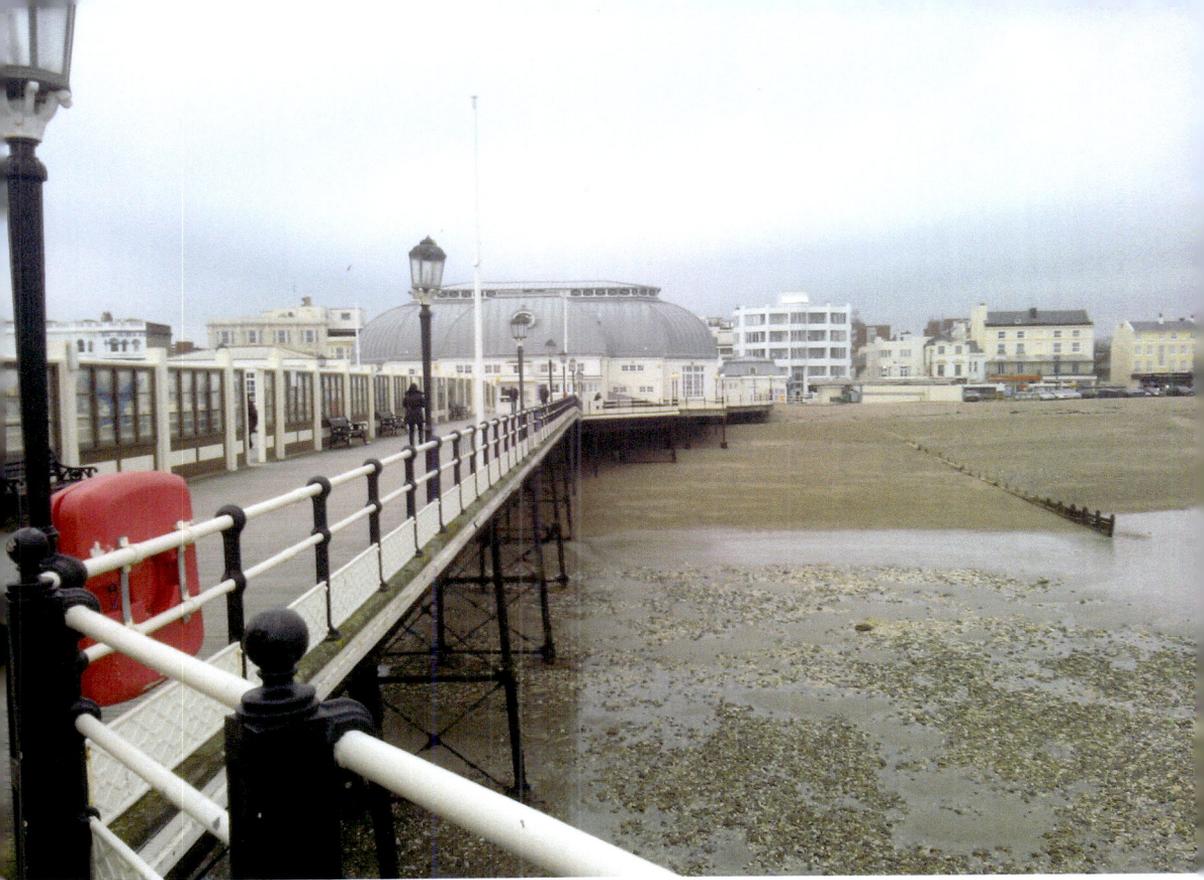

Above: Worthing Pier, once jumped over by Worthing-schooled kitesurfer Lewis Crathern.

Right: Worthing Town Hall – a dead ringer for Marty McFly's town hall in *Back to the Future*.

A

Aircraft Disasters and Triumphs

A German ME 109 fighter pilot was shot down and crashed north of Worthing on 16 August 1940 during the Battle of Britain. He then calmly got out, cheerfully surrendered and had a cigarette – his captors found that his cigarette lighter was made in Britain.

Worthing was also the site of a much sadder aircraft crash. On 10 December 1944, Lancaster PB355 was crossing Sussex on its way to bomb Germany. By the time it passed the Downs either one or two of the engines were on fire and it was drastically losing height. The pilot, Squadron Leader Essenhigh, heroically managed to keep the aircraft at enough height to avoid crashing into Worthing, although it narrowly missed a packed cinema (today's Gala Bingo) and scraped the rooftop of the Burlington Hotel. Banking round over the beach at low tide, Essenhigh tried to land the stricken bomber once safely far from Worthing. The fully loaded Lancaster unfortunately hit a wartime sea defence and exploded, killing all of the crew. Worthing escaped the huge fireball with just a few broken windows and cuts to nearby residents. Today a memorial on Worthing Pier and seven streets in Durrington remember the names of all seven of Essenhigh's gallant crew, whose actions saved thousands of lives in Worthing.

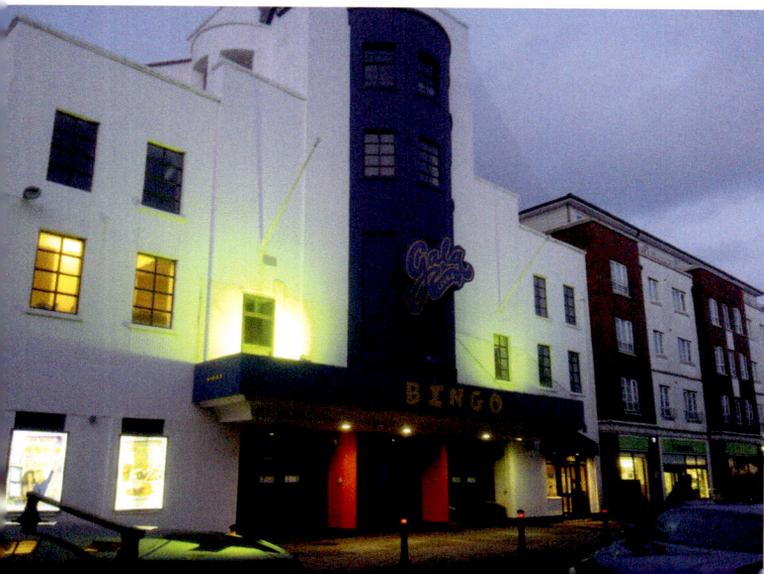

Gala Bingo Hall today, which back in December 1944 narrowly missed a catastrophic encounter with a Lancaster bomber.

The coastline from Worthing to Littlehampton was also the location of a much happier and more successful air event: the world air speed record was claimed here in 1946 and 1953 in an RAF Gloucester Meteor and Hawker Hunter.

Amelia, Princess

George IV's visits to Brighton famously helped the struggling small Sussex settlement rediscover itself, but his younger sister Princess Amelia (1783–1810) also played a role in putting the new seaside resort of Worthing on the map. Up until 1798, Worthing had been a smattering of buildings around the site of today's New Amsterdam pub (formerly the Swan), near Waitrose, and increasingly around the sea end of South Street where Worthing Pier is today. George's youngest sister, aged only fifteen, was suffering from swollen knees and so a seawater cure was deemed just the ticket. Taking her to Brighton, though, meant steeper cliffs, and the possibility of corruption by her older brother's nefarious company and parties. George III instead decreed that his youngest daughter would experience the flatter, sandier beaches of the new resort of Worthing where she could get into the sea easier and, more importantly, keep away from his eldest, naughty son.

At this time Warwick House, owned by Edward Ogle, the town's leading commissioner, was the primary holiday home for the wealthy (despite it never having a bathroom in its 120-year existence), with its prime location on the north-west corner of what is today Worthing's Steyne. It seems, however, that Amelia may have instead stayed in Worthing's only terrace of townhouses at this time: Montague Place, which had been first constructed in the 1700s but had recently been rebuilt. George apparently visited up to fifteen times and wasn't that impressed with the standard of accommodation for his little sister, but records show she was right next to the sea (which Montague Place was then) and so the poorly princess could be carried much more easily to the briny waves from there, making it a more likely royal residence. Until she left on 7 December 1798, she continued to be treated by Thomas Keate, the Surgeon General, and the frigate *Fly* patrolled off the coast to protect the princess from foreign invaders.

Despite Amelia's boost to the town's fortunes, there is surprisingly little to celebrate or commemorate Worthing's first royal visitor. Montague Place has no blue plaque due to the uncertainty of whether Amelia actually stayed there, but at least it wasn't demolished and built over with a housing development in 1896 as Warwick House (which Amelia would have been likely to visit) was. There is an office block named after her in Crescent Road and the council finally named a green space 'Amelia Park' in 1990 to celebrate the centenary of Worthing becoming a borough. Amelia would be the first of many royal visitors and drew attention to aristocrats that Worthing, not just Brighton, was a place to recuperate and 'take the waters'.

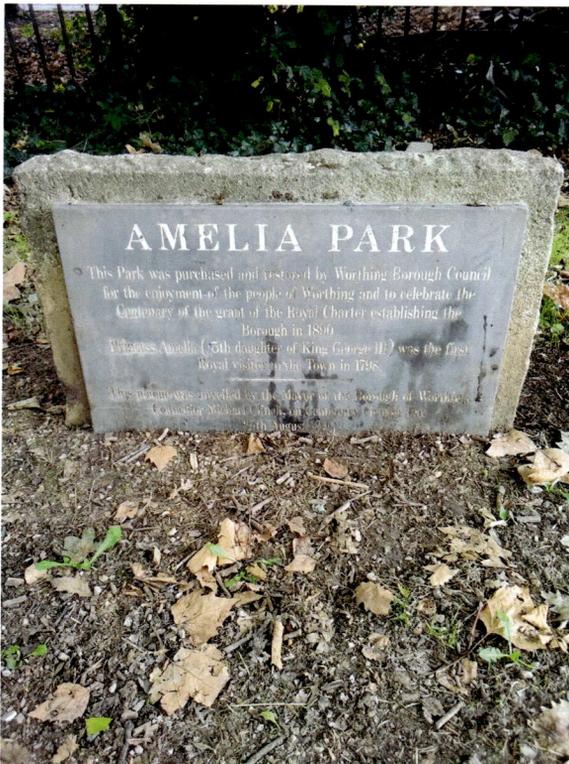

Above: Montague Place, taken in 1921. At least one of the early houses on this site was likely where Princess Amelia stayed during her 1798 visit. Other theories include her staying at Warwick House. (Courtesy of West Sussex Past Pictures, West Sussex County Library Service)

Left: Sign celebrating the naming of the gardens of Park Crescent as 'Amelia Park' back in 1990. It is one of the town's few references to Princess Amelia's visit.

Austen, Jane

While there is doubt as to where Worthing's most famous early visitor Princess Amelia stayed, there is little doubt as to where our next most famous holidaymaker and temporary resident Jane Austen stayed when she spent seven to twelve weeks here in 1805. According to Antony Edmonds in *Jane Austen's Worthing: The Real Sanditon* she may even have stayed into the new year of 1806. Austen stayed in a smaller residence than Amelia, in the building known as Stanford's Cottage back in 1805. Today it is the

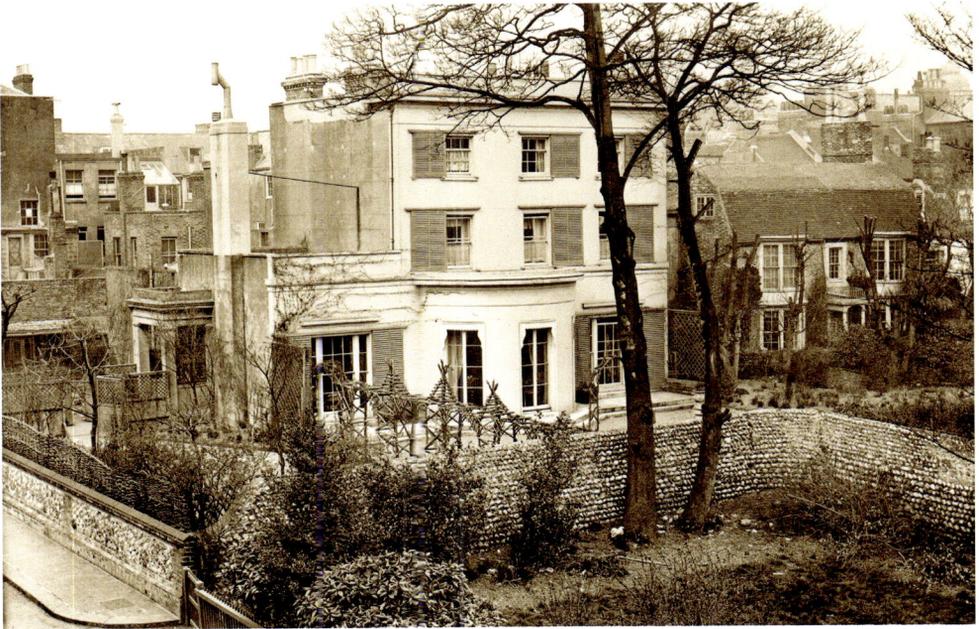

Above: Bedford House and Stanford's Cottage, *c.* 1907. Bedford House was demolished in 1940, but neighbouring Stanford's Cottage survived demolition by being used for storage due to its location behind other buildings. (Courtesy of West Sussex Past Pictures, West Sussex County Library Service)

Right: Jane Austen.

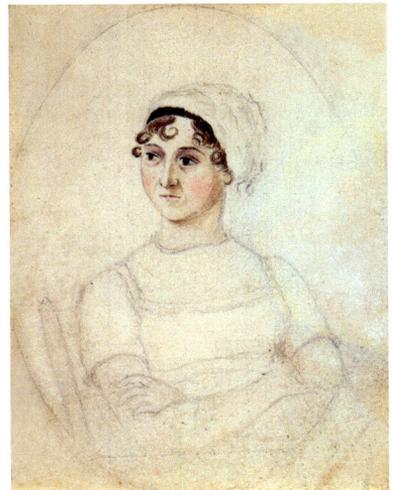

site of Worthing's Pizza Express restaurant. The length of her stay, and the fact she used her memories of the town to write a book as she was dying, suggest her feelings for the town were likely to have been pleasant. Edmonds' theory that she was inspired to use the partially constructed Worthing of 1805 as the model for the fictional seaside resort town of Sanditon, also under construction, in her unfinished final novel of the same name has now been widely accepted. Written in 1817, it made sense that Austen would have drawn inspiration from Worthing. It would be interesting to know if early drafts were ever written in Worthing (like any of her other novels that she attempted much earlier than their publication date) and if, as Edmonds explores, she made a later visit to the town. If so, the Jane Austen-themed Pizza Express we can eat in today deserves to be cherished even more as a place of homage for Austenites everywhere, and the town definitely deserves a Jane Austen cultural centre. Locals should be proud

Stanford's Cottage, 1963, when the building belonged to Messrs Moore and was used as storage for their furniture shop. (Courtesy of West Sussex Past Pictures, West Sussex County Library Service)

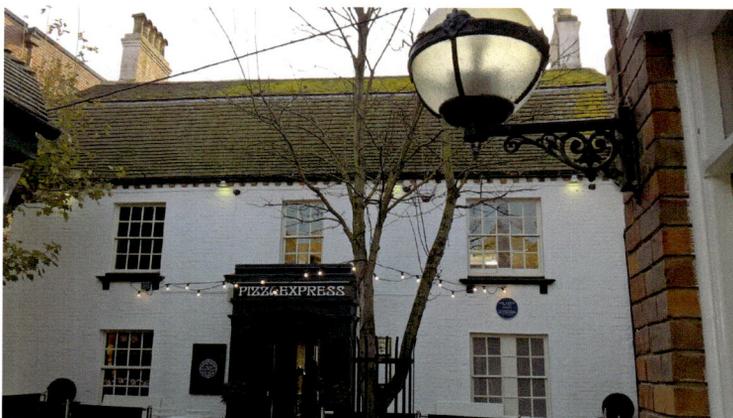

Stanford's Cottage, now a Pizza Express restaurant.

that Austen likely spent merely hours in Brighton, but months in their town. Brighton may be mentioned in *Pride and Prejudice*, but it is Worthing that helped inspire what would have been a whole novel had Austen survived.

Augusta, Princess Sophia (1768–1840) and Other Royal Visitors

Antony Edmonds argues convincingly that Mr Parker's Trafalgar House in *Sanditon* is likely to have been inspired by Edward Ogle's Warwick House, which existed in Worthing in 1805. Decades later Worthing had a real Trafalgar House, and it was in this seafront house in Marine Parade that Princess Sophia Augusta (the sixth child of George III) overwintered in 1829–30. Like *Sanditon*'s creator, Jane Austen, she too stayed off-season, but her visit was far greater known about and helped inject some much needed interest and investment into the town, which was suffering a slump both in fortunes and status at this time. Following her stay the building was renamed after her, becoming Augusta House, but was sadly demolished in 1948. The 1980s block of flats on Marine Parade today is also named Augusta House and helps us remember this other royal visit, but it is a shame we cannot see the original building that the daughter of George III stayed in.

Sophia Augusta is not to be confused with Princess Charlotte Augusta (1796–1817), granddaughter of George III. Charlotte would have been queen following the death of her father, George IV, had she not died in childbirth, and Worthing was very fond of this potential monarch. In another branch of the multiverse, where Charlotte's death didn't happen, Queen Victoria would have remained a minor member of the royal family and the resulting timeline of royal and even international history becomes very different. This 'Charlottean Age' would have given us very different European monarchs; for example, there would have been no Kaiser Willhelm II, Victoria's grandson, who became Emperor of Germany and thus played a major role in the onset of the First World War.

Perhaps then we should mourn the early death of this queen that never was for a number of reasons. Worthing greatly mourned Charlotte's death as she brought much popularity to the town when she stayed in Warwick House in July 1807, nine years after the visit by her aunt Amelia to Worthing. As with his sister, Amelia, George once again made the journey over to Worthing to visit his daughter, and was presumably happier with her accommodation this time. Had Charlotte become queen, perhaps further visits may have led to Worthing having its own Marine Pavilion where she may have had her own seaside bolthole and the town possibly even becoming 'Worthing Regis'. Charlotte, more than any other, is the visitor to Worthing who provides the most interesting avenues for counterfactual historical discussion.

Another royal visitor was Caroline of Brunswick (1768–1821), who stayed in Worthing for a week in May 1814 when separated from her husband, the future George IV. She

also stayed in a building where Sompting Abbots school is today before emigrating to France, taking the frigate *Jason* from the Sussex coast. Three years later Ernest, Duke of Cumberland (1771–1851), also stayed at Warwick House. He patronised the Theatre Royal while here, occupying the royal box. I would love to say he enjoyed some sausages on his visit too, but sadly there is no historical evidence of that being the case.

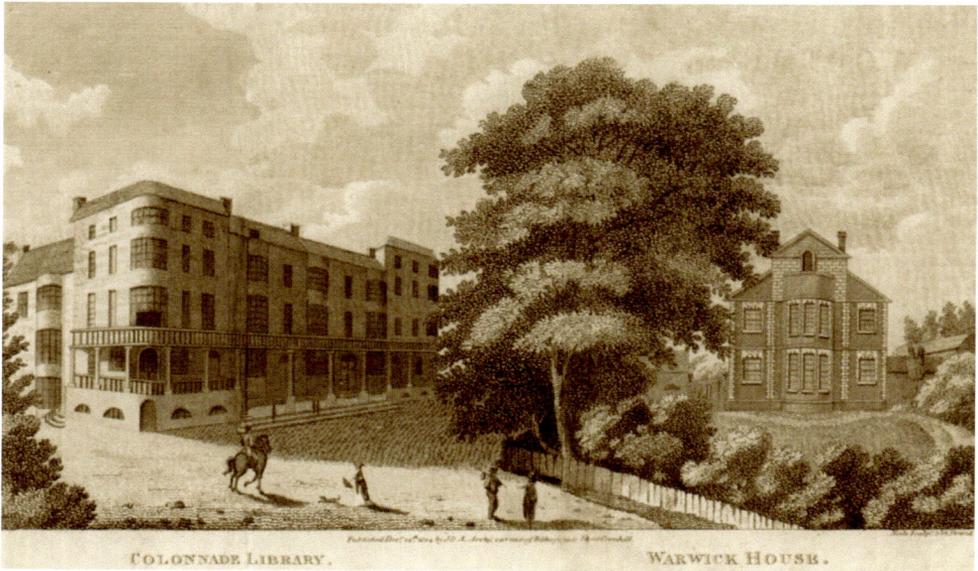

Warwick House and gardens, 1804, residence for at least two royals. (Courtesy of West Sussex Past Pictures, West Sussex County Library Service)

The Broadway today on Brighton Road, site of the former Warwick House and gardens. (The building in the distance at the rear can also be seen in the 1804 picture above.)

Above: The east side of the High Street.

Below: New Warwick House was built in the grounds of the former house and gardens.

Bandstand

On the site of what is today Worthing Lido, there was once a 'birdcage' bandstand. It was once seen as vital that each seaside resort have an area for live outdoor music, that is until the Second World War, when overseas holidays, LP records and television changed people's habits. Before that happened, though, the site would be expanded over the sea to its current size with space for over 2,000 deckchairs in 1925. Between 1959 and 1967 half of the site became an unheated open-air swimming pool, which is why the site is still called 'The Lido'. The promenade by the site has recently been used for a Walkers Crisps advert with Gary Lineker and was a location used for filming the 2019 film *Stan and Ollie* starring Steve Coogan.

Budd, Captain C. H. B.

On 31 March 1930, Worthing gained a claim to infamy when it became the first place in the country to elect a fascist town councillor. This occurred when Captain Charles Harry Bentinck Budd became the independent councillor for Ham Ward in Broadwater, surprisingly beating the popular incumbent. He also went on to become a county councillor for the Offington Ward of West Sussex County Council as well as the chief of the Sussex and Hampshire League of Fascists.

Budd had served in the First World War, where he was struck in the head by three machine gun bullets at the Battle of Loos, one of which lodged in his brain. This meant that from then on his right hand and foot were paralysed, his memory occasionally failed him and he also tended to have intermittent bouts of blinding headaches. This background gave many the explanation for his fascist tendencies, but there had also been mental illness in the family as his paternal uncle was declared insane and committed to a psychiatric institution.

Budd's first dalliance with fascism dated back to 1923 when he was in Italy on business in the country's earliest days of fascism. He stayed as part of a British government commission to study the regime, not returning to Britain until 1926. Four years later, the independent councillor was now representing a ward of Worthing, and

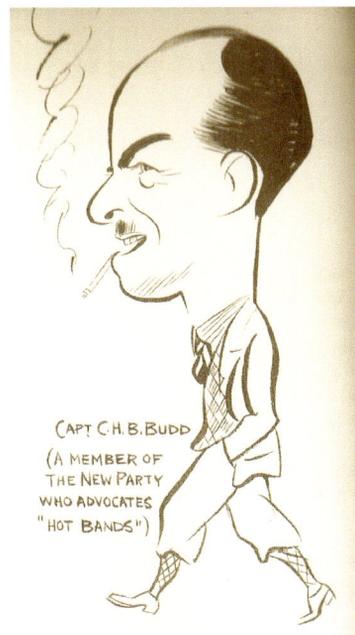

CAPT C.H.B.BUDD
(A MEMBER OF
THE NEW PARTY
WHO ADVOCATES
"HOT BANDS")

Councillor Charles Bentinck Budd. (Courtesy of Worthing Museum)

by 1932 Budd had joined Oswald Mosley's 'New Party', which later became the British Union of Fascists (BUF). The BUF was created when Mosley left the Labour Party following their rejection of his ideas regarding unemployment. Mosley had also been linked with the Conservatives and Liberals too. One of the New Party's first branches was set up in Worthing, and BUF leader Mosley was to be a frequent visitor, publicly speaking here on four occasions, as did Professor William Joyce, who became better known as 'Lord Haw-Haw' in the Second World War. The New Party became the BUF after Mosley's visit to Italy in 1933, the same year that Budd was re-elected. Black Shirts became a familiar sight around Worthing in these years, publicly marching on the seafront, up the main streets such as South Street, and selling their newspaper *Action!* on street corners. The Fountain pub (today the Slug and Lettuce) in Chapel Road became their favourite drinking den, which seems strange when we learn it had become a favourite of Rastafarians by the 1960s. It takes little imagination to consider what Mosley's thugs would have thought of that group and vice versa.

Chris Hare, in *Worthing: A History*, relates how 'many of the young men who did join the fascists in Worthing were either new to the town or of Italian extraction'. The Worthing branch of the BUF, the New Party, was to become one of the most successful in numbers and profile in the whole of the south of England. This early popularity was soon to ebb after 1934, and what we must remember is that at this early stage there were few associations yet with Nazi Germany as, of course, before January 1933 Hitler wasn't even in power. Nevertheless, this new organisation had objectionable views from its earliest days.

An idea of the growth in numbers at this time is demonstrated in 1934 when a lone gunman was reported to be on the run from the police on the Downs, north

of Angmering, around Tolmare Farm, off Long Furlong. The police were offered a search party of 100 Black Shirts by Budd to track down the gunman. They refused the offer, according to Michael Payne, author of *Storm Warning,* perhaps wary of letting 100 uniformed individuals with strong views loose as vigilantes.

The first time that the national leadership of the BUF made its presence felt in Worthing was a year before this, though, on 7 October 1933. Mosley wrote a letter to the *Worthing Herald* that started: 'Sir, Fascism is coming to Worthing.'

By 1 December of that year the BUF had held its first meeting in Worthing, to a packed crowd at the old Town Hall, leading to the town being dubbed the 'Munich of the South' in the press. Several leading figures in the town took a stand against this, including the admirable headmaster of Worthing High School at that time, the pacifist Mr Rolfe. G. Martin. In his comments in 1933 on the lack of further support for fascism in Worthing, he attributed it to 'cold common sense among those who have had the best education Worthing could offer'.

Both the High School for Boys and Girls at this time faced their pupils being handed recruitment flyers for the BUF outside their school gates. Mr Martin went on to say at a dinner of ex-pupils, that he was glad no Black Shirts were present. He permanently excluded one boy who turned up in a black shirt, whereas a Worthing High School girl was just sent home to change her black blouse. Martin would go on to invite German boys to Worthing in an attempt to try and engender peaceful friendship between the two nations in the hope that youth would be able to stem the tide of war the older generations were sailing on.

In 1933–34 the *Herald* ran a number of articles on Budd, worryingly demonstrating how impressed it was with the councillor; the articles focussed on how 'dynamic' and 'young' he was. However, by 1934, the *Herald* had thankfully turned against the fascists.

By 1934, the Worthing branch of the BUF had opened on the top floor of No. 23 Ann Street – it later moved to No. 59 Ann Street, then to an office at No. 37 Warwick

Ann Street today, the former site of one of the BUF's headquarters in the town in the 1930s.

Street. Ann Street was not only home to two of the BUF's offices, but also, bizarrely, the Worthing Police Station at this time. Today the north half of Ann Street has been replaced by the Guildbourne Centre and its flats. The Sussex/Hampshire office for the BUF was also based in the town, at No. 27 Marine Parade.

Earl Winterton, the town's MP, said of the fascists in 1930: 'I have no quarrel with the Fascist Party and I hope the Fascist Party has no quarrel with me.' By 23 February 1934, he finally openly reversed his position about them at the meeting of the men's branch of the Conservative Association at the Pavilion. This was also the year in which fights between fascists and anti-fascists broke out in large numbers in Worthing, two years before the famous battle between working-class Londoners and the Far Right at Cable Street. Budd would be heavily involved.

In 1934, with Hitler consolidating his power in Germany, the main fascist focus in Worthing moved from Budd to the party leader, Oswald Mosley, who made a series of high-profile visits to the town. Worthing became prominent for the fascists due to its proximity to Abingworth Hall, near Thakeham, a few miles north-west of the town, which Mosley had leased as his residence. Mosley's talks in Worthing achieved big audiences, but also attracted large crowds of anti-fascist protesters, with the most famous talk in 1934 leading to a massive street brawl where Mosley could have lost his life. Following this event, Budd actually asked the police to arrest *him* for physical assault, according to Michael Payne in *Storm Tide*. This was probably to show that he had been involved as much as Mosley in the physical attacks, as Mosley had been injured and many fellow Black Shirts were indeed now black – and blue. Sally White, in her history of Worthing, tells how 'within a week, summonses had been issued for Mosley, Budd & Joyce – they were charged with riotous assembly and committed for trial at Lewes, but the case was dismissed for lack of evidence'.

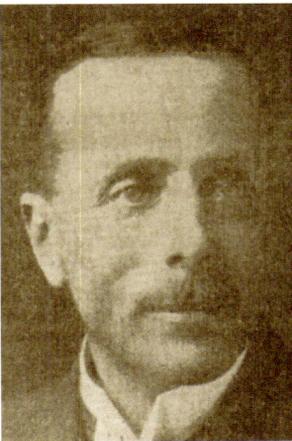

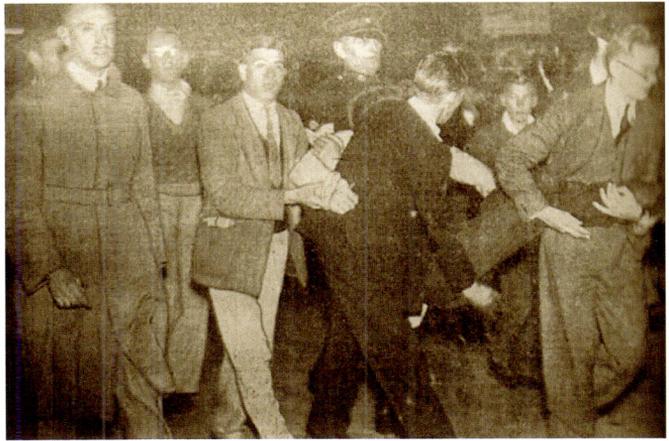

Above left: Earl Winterton, Worthing's MP at the time of the fascists. (Courtesy of National World)

Above right: The BUF, 9 October 1934. (Courtesy of National World)

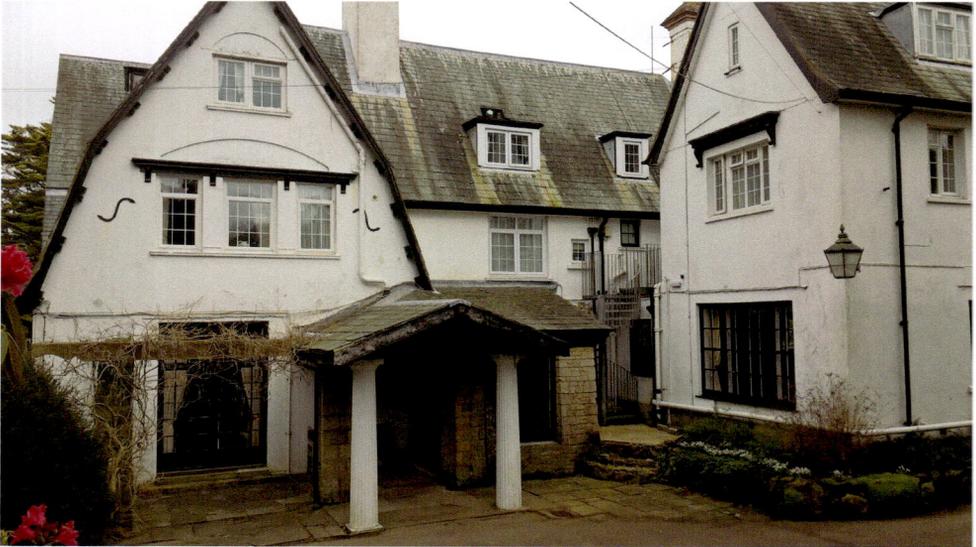

Abingworth Hall, Thakeham, north-west of Worthing, once home to Mosley.

By 1935, with the growing unpopularity of the BUF due to the actions in Abyssinia of the Italian fascists, Budd left Worthing and took up a position in the BUF in the Midlands. He visited Rome the following year and communicated with Mussolini's secretary afterwards. This was possibly one of the reasons, along with his fascination with both the Italian and German leaders, why he was interred during the war for longer than most of the other fascists.

In June 1940, on Churchill's orders, 800 fascists including Budd were arrested and detained. The county with the biggest percentage – over 100 of the 800 nationwide – was West Sussex. It wasn't just men either. Doris Conley of Gratwicke Road, who was effectively the female leader of the BUF in Worthing, wasn't interred but was eventually imprisoned for six months in 1940 for trying to get a corporal to desert his unit.

By 1941 Budd had rejoined the unit he served in during the First World War. He was arrested and was one of the last fascists to be released – not until 1944, by which time, as Chris Hare reports in *Worthing Under Attack*, 'he was said to be in poor health'. Had Budd remained at his former Worthing home in Grove Road, he may well have been in even worse health, however, as in February 1943 Worthing suffered the last of the Luftwaffe's bombing raids, and some of its worst, including a raid on Grove Road, where Budd had lived at Greenview.

After the war, Budd and the other BUF members were watched by the secret services – Budd until 1954. It appears he returned to the Worthing area, living near Ashurst, and one local resident found him a 'changed man' also according to Chris Hare in *Worthing Under Attack*. Budd, presumably tired of being watched by MI5, seems to have emigrated, as did fellow fascist Jorian Jenks, who died at the age of sixty-four in 1963.

Budd's mistress and fellow fan of the Führer, Enid Baker, became his last wife after the war, and she died in 1996 in Surrey. Thankfully, the family seemed to move away from Budd's fascist beliefs, as his grandson married a woman with a Jewish surname.

Butcher, Pat (Pam St Clements)

The Warren School in Worthing, later site of Aviva insurance and today Worthing College, was once where Pam St Clements, formerly Pat Butcher on *EastEnders*, attended. The school started off on Ashacre Lane, but by the 1950s when Pam was there it was in its final location and provided the future actor with 'seven fulfilling years', despite its predictable and sometimes hated food.

Her time at Worthing was where she first developed a taste for the stage, and as Antony Edmonds recounts in *Lost Buildings of Worthing*, she not only debuted in *Vanity Fair* and *Pride and Prejudice*, but was also president of the Drama Society. Her other passion was horse riding and so she encountered the eccentric Captain Willy, who looked after the school's horses in its own stables. Possibly due to the fact he sounds like the worst-ever superhero, he was understandably nervous around the students at the school. I'd like to think it was just because he knew he was in the presence of a soon-to-be acting legend, one whose career would become as big as her famous on-screen earrings.

Pupils at the Warren School, which Pam St Clements of *EastEnders* once attended. Today Worthing College occupies the site.

Castle Goring

Worthing may not have been important or strategic enough in the Norman era to boast a medieval castle, but it does have a 'sham' castle of historic importance in Castle Goring. There are not many houses in the United Kingdom that are a homage to not just one, but two buildings simultaneously. Likewise, there are also not many houses where if you don't like the architectural style of your building, you can walk around the other side of the house and witness a completely different architectural style. Castle Goring is one of these, with its Gothic north front, designed to replicate the medieval style of Arundel Castle, and its classical side to the south, said to be an homage to the famous Villa Lante near Rome. It even has a corridor that starts off Gothic one end and ends up in the classical, Greco-Roman style at the other. This little-known stately home, visited by Oscar Wilde and Queen Victoria in the early years of her reign, was a collaboration between Sir Bysshe Shelley, of the local landowning family, and a local architect responsible for several great Worthing buildings, John Biagio Rebecca. It was the only building the Shelley family ever commissioned, making it even more special.

Bysshe Shelley built the house not for his son, Sir Timothy Shelley, but for his grandson, the poet Percy Bysshe Shelley, at a cost of £90,000 between 1790 and 1805. Had the famous poet not drowned in Italy at the age of twenty-nine, he was due to be the house's first inhabitant. Instead, his wife, Mary Shelley, the famous author behind *Frankenstein*, sold the mansion. It is amazing to think what it would have been like as the home of this amazing literary couple and their offspring. Instead, Castle Goring's fate was a mixed one until author, socialite and reality television personality Lady Colin Campbell purchased the building in 2013 for £700,000. It needed over £2 million worth of repairs, especially to the roof, which had £50,000 of its lead stolen in a 2012 break in. Walls were crumbling and numerous windows had been smashed. Famously appearing on *I'm a Celebrity, Get Me Out of Here!* in 2015 to raise funds to repair the house and its leaking roof, 'Lady C' saved the house and is now the genial hostess at many functions at the house. The building is now thankfully a successful conference, event and wedding venue, with increasing numbers of bookings following the televised story of Lady Colin's challenge of

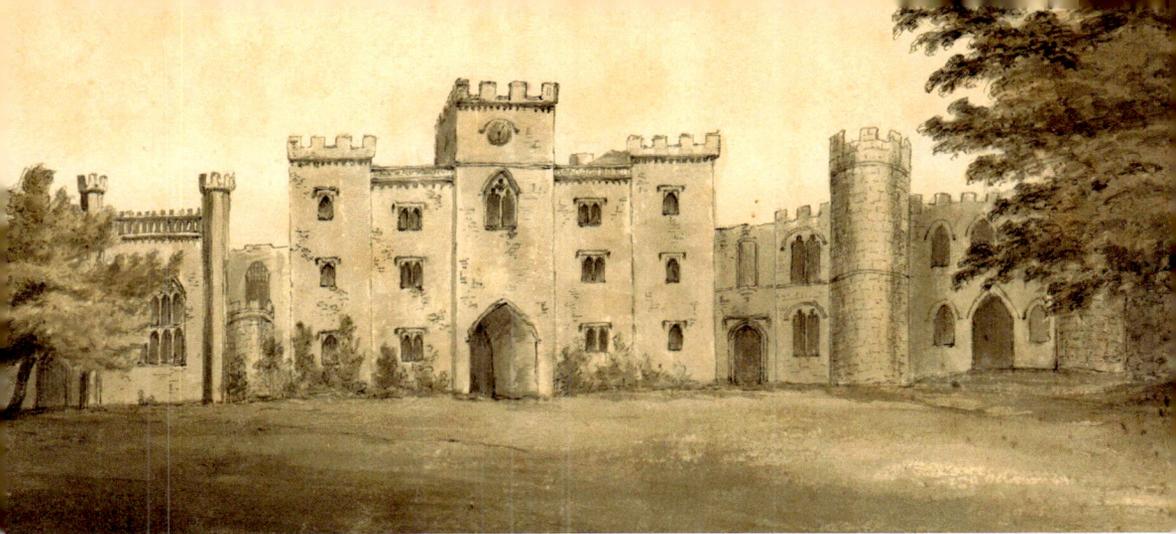

Castle Goring. (Courtesy of West Sussex Past Pictures, West Sussex County Library Service)

restoring the building in time for its first event. Sussex is indeed incredibly lucky to have this 15,600-square-foot, eighteenth-century architectural masterpiece.

Celebrity Citizens

Desmond Llewellyn, who played Q in the Bond films for many years, lived in Grand Avenue in Worthing in the 1960s and very sadly died in the early 2000s on the A27 near Firle. In 1978, *Game of Thrones* actor Gwendoline Christie, who played Brienne of Tarth in the show, was born in Worthing. She also played Captain Phasma in Star Wars, first appearing in *The Force Awakens*. Liz Smith MBE, who played 'Nana' (Norma Speakman) in *The Royle Family* and also starred in the *Vicar of Dibley*, was often found out and about in Worthing in her final years. Liz sadly died in 2016 at the age of ninety-five. One of her last acting roles was in *Charlie and The Chocolate Factory* alongside Johnny Depp. Jamie Hewlett, designer of *Tank Girl* and co-creator/songwriter for animate band Gorillaz (along with Damon Albarn) went to Northbrook Art College in the town.

Churches

Worthing itself may not be the oldest settlement in Sussex, but it had a chapel in the Middle Ages, the location of which is sadly unknown. Some historians have placed it with the lower town or 'Worthing shops', which were located on what is today the beach, washed away in the storms in the early eighteenth century. Other historians have sited it around the New Amsterdam and Corner House pubs, with the churchyard possibly having been where the New Amsterdam's pub garden is now. Neighbouring Heene village certainly had a chapel back in the Middle Ages, as the remains are still visible today on the east side of St Botolphs.

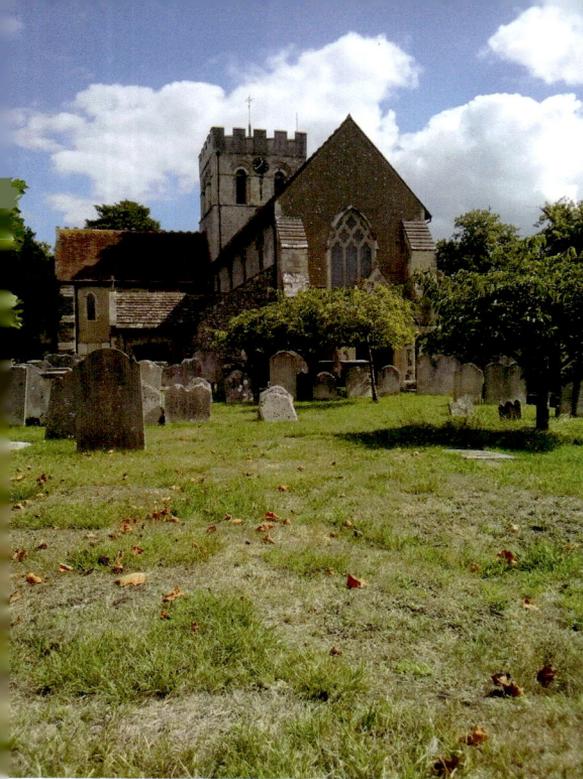

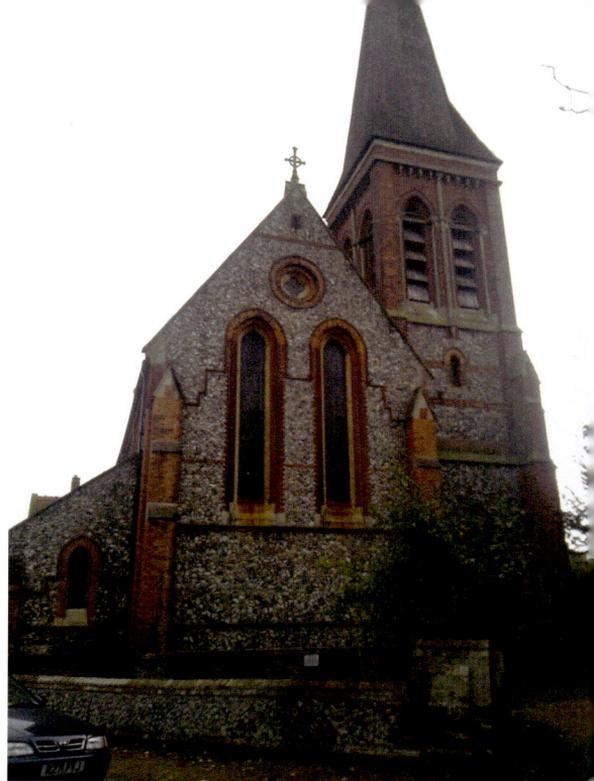

Above left: St Mary's Church, Broadwater.

Above right: St Botolph's, which houses Heene Chapel in its grounds.

Below: The remains of the medieval Heene Chapel.

Worthing folk at the time of Jane Austen's visit in 1805/06 had to walk up the High Street, through what is now Ivy Arch and across the fields to St Mary's in Broadwater for their services as the town had no church of its own at that time. This was all to change in 1812 when St Paul's was built as a 'chapel of ease' (i.e. it eased the pressure of the number of attendees to the parish church at St Mary's), eventually becoming the town's first own parish church.

Christ Church in Grafton Road followed between 1840 and 1843 and was aimed at the poorer, fishing communities. One of its galleries, visible today on the south side of the first floor, was known as the 'Fisherman's Gallery' as the Victorian fishermen tended to smell badly and so were separated from the rest of the congregation downstairs. One of its more famous visitors in the last few years was the one and only Yoko Ono.

Next door to Christ Church is the Spiritualist Church, officially opened by Sherlock Holmes' creator, Sir Arthur Conan Doyle, in 1926, who himself was a spiritualist. The two churches clashed in 1979 when the vicar of Christ Church claimed the spiritualists were summoning spirits of the dead from the graves in his church. The spiritualists seemed to have largely ignored him and the complaints seem to have subsided when the curate moved away to another parish. Those spending time within Christ Church

Below left: Christ Church.

Below right: Worthing Spiritualist Church.

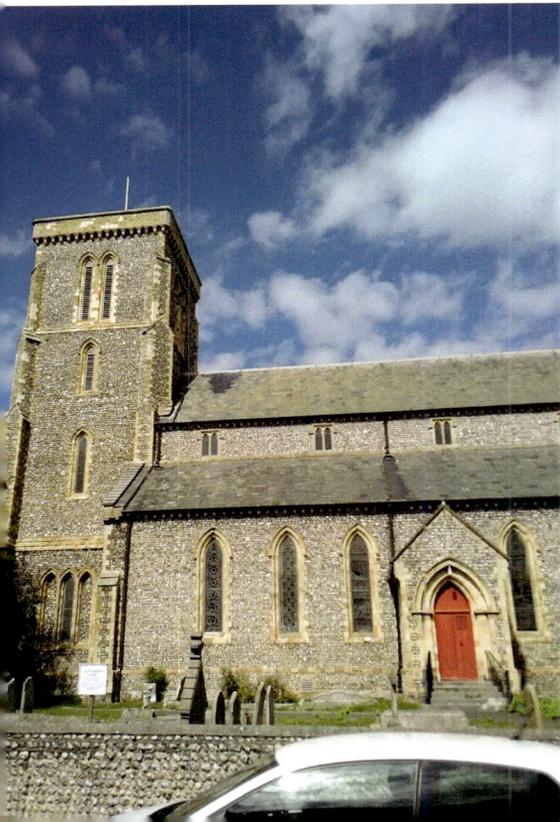

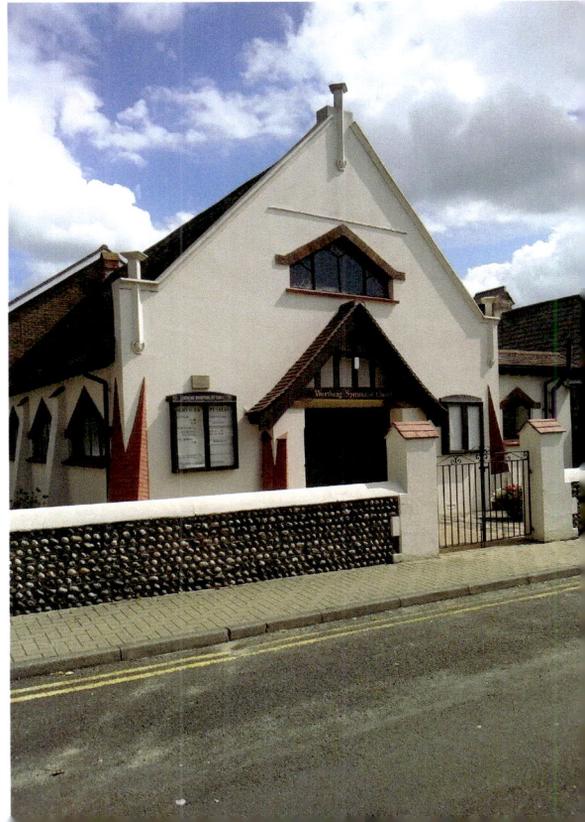

would have something far more horrible to contend with in the twenty-first century than the sounds of the dead, however – more of which later.

Cissbury Ring

Cissbury (further east of Highdown and just north of Worthing) was once thought to be the main fort in the area and Highdown its southerly lookout annexe, but this was disproven when it was realised that Highdown was in fact much older. The National Trust, which owns the site, has described it as 'the most historic hill on the South Downs'. It certainly has the Pride of Sussex, as well as being somewhere that makes Sussex proud – 'Pride of Sussex' is the name for the round-headed Rampion flower that has been adopted as the county's official flower. Worthing is proud of its highest peak too, with the highest point of Cissbury reaching 183 metres (602 feet) since its incorporation into the borough in 1902. This sense of pride is well justified as it is also the second biggest hillfort in the whole country, pipped to the post by Maiden Castle in the West Country, but Cissbury is still one of the biggest of its type in Europe. Cissbury truly belongs not just to the nation but to the people of Worthing too, as the money to buy Cissbury was successfully raised by townsfolk in the 1920s before it was happily handed over to the National Trust.

Locals may have eventually purchased the hill, but it was incomers from far away who were likely to have constructed it. Cissbury's fortifications are estimated to have been constructed around 250 BC by the second of three waves of invaders from Gaul, today part of France. If they weren't, then Cissbury was built to counteract the Gaulician invasion. Whoever built it, it was at remarkable speed, as the fort is believed to have been constructed in just one summer by thousands of slaves or local folk. If it was built this speedily by defenders, then it shows the fear and urgency this invasion from abroad provoked. The 10,000-odd whole tree trunks needed to build the wooden walls surrounding the 24-acre fort, and removal of tonnes of chalk, shows the importance of this area and the severity of the invasion.

Cissbury has faced two far more recent invasions: firstly, the A27 potentially passing by or, even worse, going through it, which has thankfully been averted; the other was the development of housing nearby, which has not been as successful. Nevertheless, the only invasion Cissbury faces today is that of contented walkers and ramblers, happy to climb somewhere with such amazing views.

Cricket

Sussex has a rich history of cricket. Brighton was once the home of the royal cricket pitch (today the Level) and Lewes has evidence of being the site of one of the oldest games ever played. Highdown Hill, outside of Worthing, though, was once the site of

a most unusual cricket match in 1812 between the gentleman of Sussex's coast versus those of the Weald – and they each played on their respective side of the peak of the hill. A less challenging location to play was Worthing's beach, which also was a venue for cricket matches in the early days of the resort, helped by the generously wide and sandy beaches at low tide. Today's home of Worthing cricket is Broadwater, with both cricket being played on the green at Broadwater across from the Cricketers pub and at the Manor Ground (previously part of Broadwater Manor land), where Worthing Cricket Club has been based since the nineteenth century. The club has been playing since 1855 and was formed from both a Broadwater club and a second club based in Homefield Park. There is evidence of a game being played against Henfield at Crescent Park as far back as the 1840s.

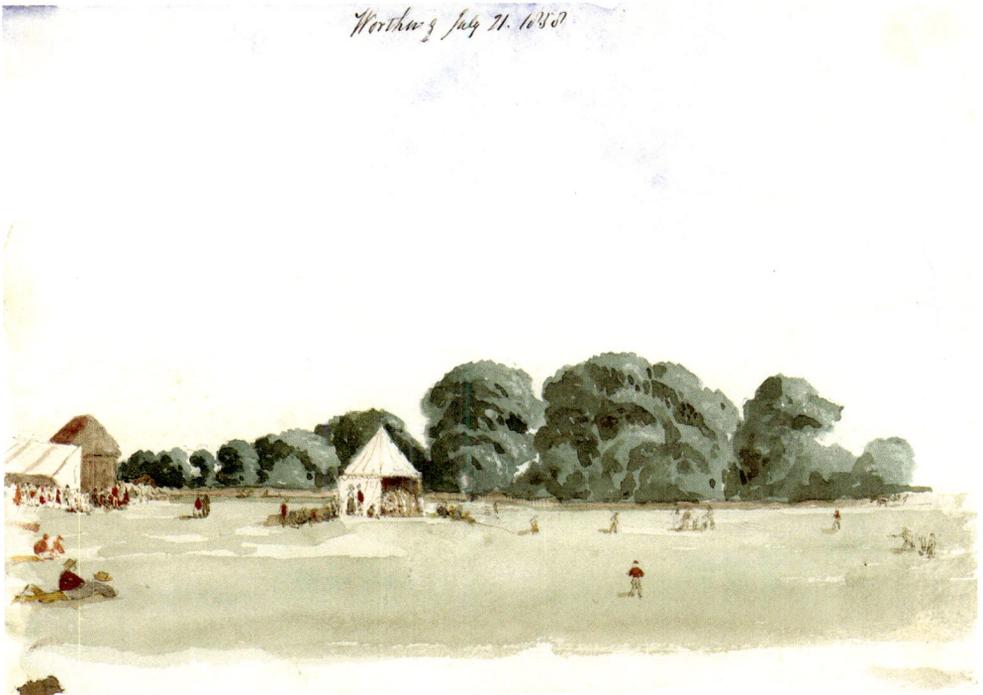

Worthing July 21. 1858

Cricket being played on Broadwater Green, *c.* 1858. (Courtesy of West Sussex Past Pictures, West Sussex County Library Service)

Davison, Emily Wilding

Today's Beach Residences, the prominent twenty-first-century building next to the Burlington, was formerly the modernist/art deco Beach Hotel until its demolition. Before that, in its first guise, the site was a terrace of Victorian townhouses, which at one point was the Prince Albert Convalescent Home. Before becoming a convalescent home, one of the houses in the terrace was a school where the famous suffragette Emily Wilding Davison taught.

Dome, Cinema

Worthing's Dome Cinema is one of the oldest in the country. Brighton's Duke of York narrowly pips it in the longevity stakes, though, opening a year before in 1910. The Dome was first opened on 15 April 1911 by local entertainment impresario Carl Seebold as a multipurpose entertainment facility, and at first was largely dominated by roller skating – the centre even had its own roller-skating team. The building was only fully completed on 7 October 1911, when the front section opened and the dome at the top of the building was fully completed. At that point a cinema screen was opened upstairs (the current Screen 2 sits partly on that site). It's believed that £5,000–6,000 was spent on the building. It was originally named The Kursaal after similar entertainment sites across Europe that Swiss owner Carl Seebold had seen (he had worked at one in Southend before moving to Worthing). In 1915, the building was renamed due to anti-German sentiment over the First World War. A competition was run in the local paper for a new name, and the prize of £1 was offered. The name tended to be used in Switzerland rather than Germany, however, and meant 'cure hall', so the name change was technically pointless. It should be of no surprise, though, as there had been similar efforts to distance from German names elsewhere; for example, 'dachshund' was changed to 'sausage dog' after some of these dogs were stoned by thuggish so-called patriots, and the royal family famously changed their name to Windsor from the historic Saxe-Coburg and Gotha.

The Dome, one of Worthing's most famous buildings.

Just prior to the war in 1913, a meeting was held by the WSPU (suffragettes) in the building. The women held a rally, which drew large numbers but also anti-suffrage sentiment from locals. As a result of a gathering hostile crowd, the women needed to make a swift exit using the building's rear doors. Suffragette rallies were no longer needed after the war due to many women getting the vote and the growing popularity of cinema. As such, the building layout was swapped over in 1921 so that the downstairs was converted into a cinema and the upstairs became a ballroom. The current interior of the cinema is largely the same as it was in 1921, so today a trip to the Dome is like a trip back in time, and it remains Worthing's most famous building after the pier.

Edward VII

Edward VII made a number of visits to Worthing, commemorated by blue plaques on the Warnes building, as he visited the Warne's Hotel on the site, and also at Beach House. Recent investigations by Antony Edmonds in *Lost Buildings of Worthing* have cast doubt on the persistent belief that he stayed overnight at Beach House, which at the time was owned by the Loder family. Antony questioned how well the king knew Loder and surmised that it was more likely that the (then private) gardens were left to the king for his discretionary use, who at that time was recuperating from illness. The gardens became public in 1924, according to Paul Holden of the *Worthing Journal*, and so by 1907/08 they would have been an oasis of calm. Edward's driver stated the king would have appreciated a place of peace and quiet after being mobbed by a crowd on the pier, so it makes sense he would have made use of a place of respite rather than a residence.

Beach House.

English Martyrs Church

Coach parties come from all over the country to Goring-by-Sea, which might surprise many who know of the beaches but little else in this pleasant residential suburb of Worthing. If it was a National Trust property Goring Hall might have been a hotspot for visitors, due to its royal connections, but today it is a private hospital. Instead, visitors come to Goring for one of Sussex's lesser-known secrets: the amazing ceiling at English Martyrs Church, which has between its unimpressive 1960s walls a painstaking recreation of the Last Supper on the Sistine Chapel. Talks are available by the church's knowledgeable staff. The best thing about the chapel is that you can actually see its ceiling without craning your neck as you do at its namesake in the Vatican.

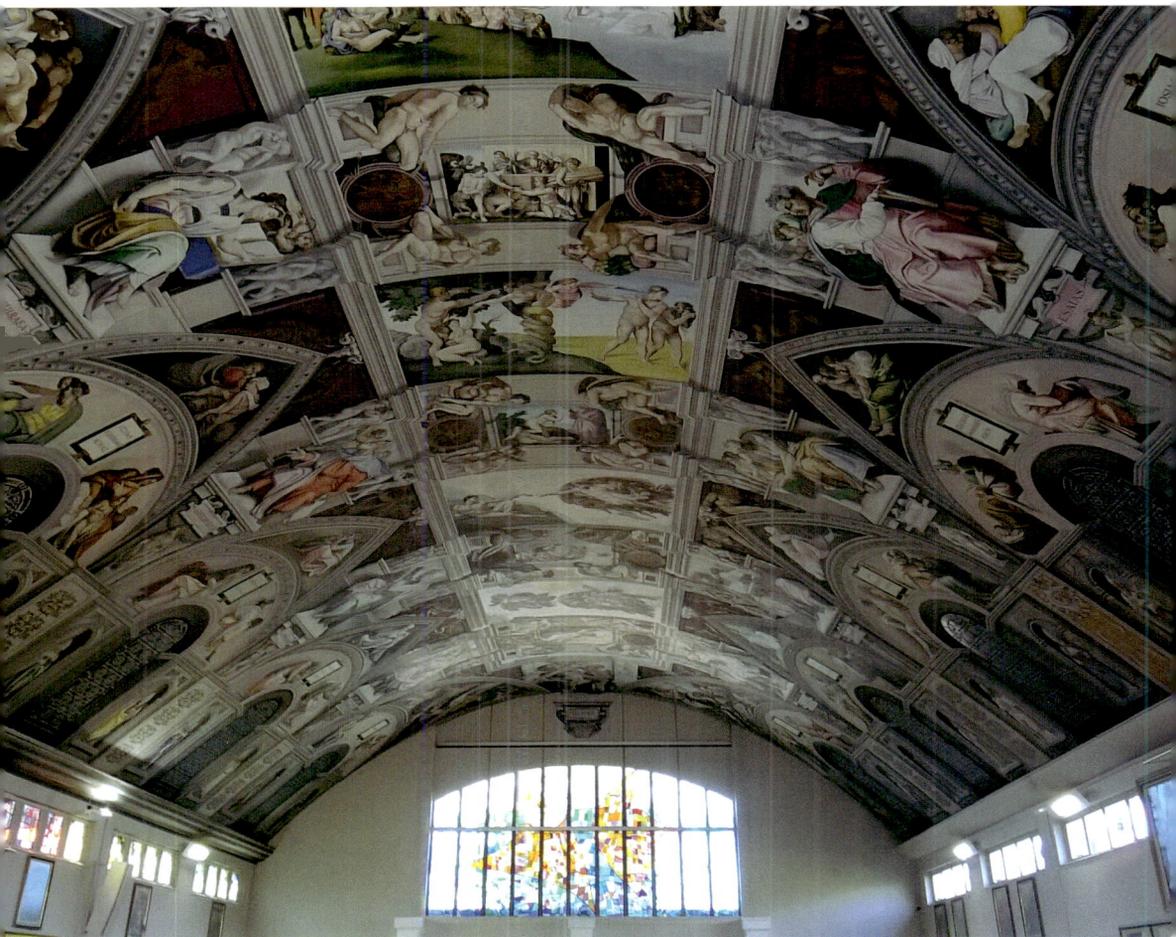

Above and overleaf: The interior of English Martyrs Catholic Church.

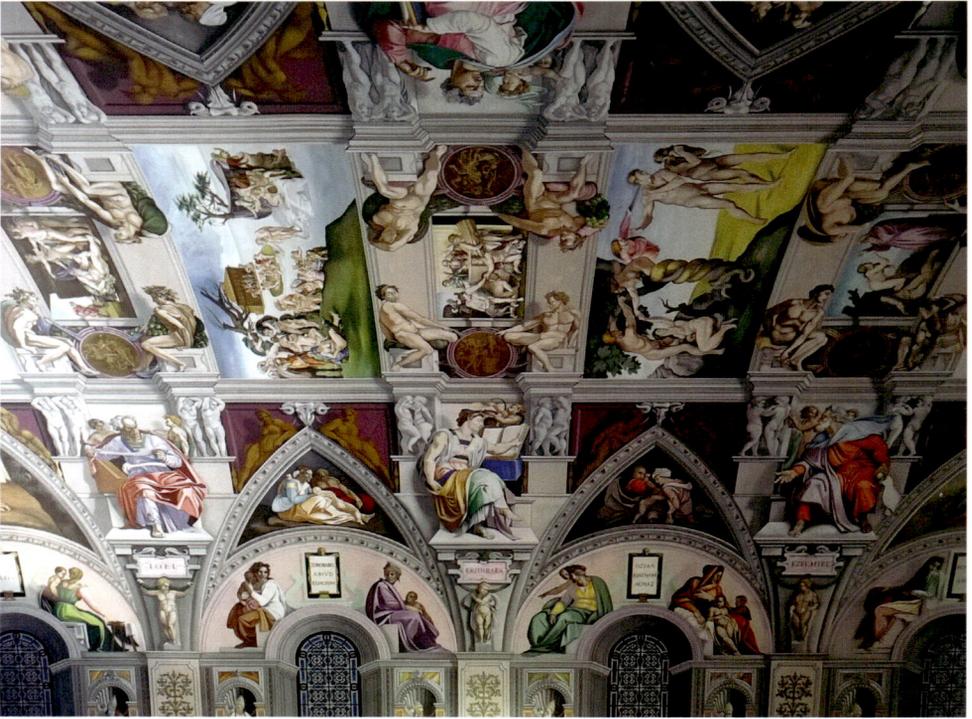

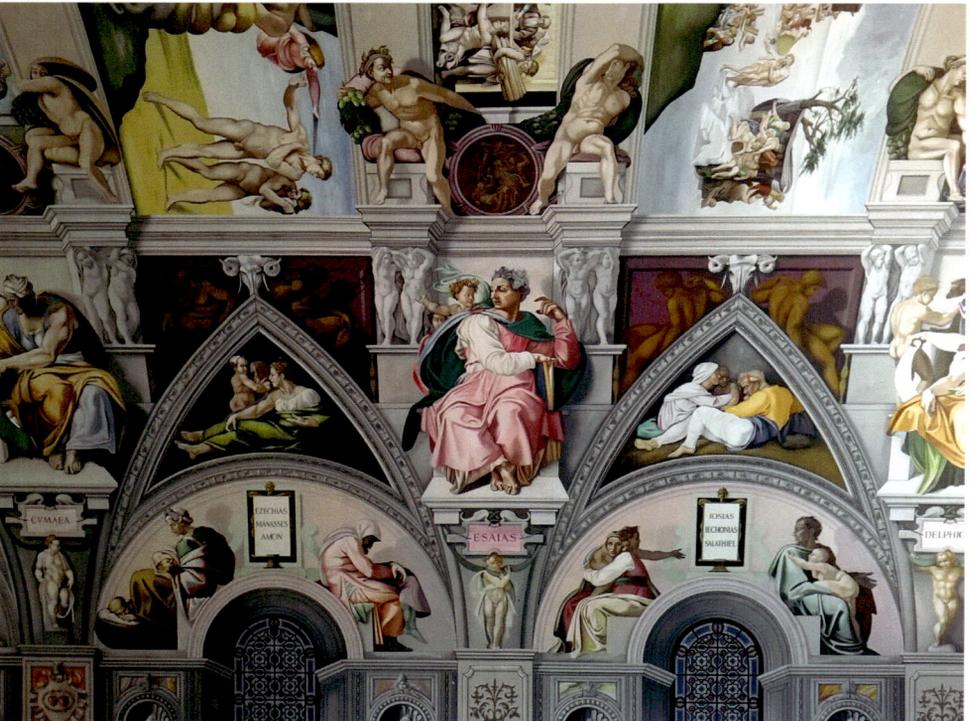

Errors

In 1989, the naming of a new block of flats on the seafront in West Worthing was intended to honour the *Capella*, a ship shipwrecked there nearly a century earlier, but the name was accidentally misspelt and the building became 'Capelia House'. Errors have also been in tales about the town and its environs over the years. A story exists that one of the tunnels created by Neolithic miners at nearby Cissbury Ring went all the way to Offington Hall, where snakes were said to protect buried treasure there. It has been suggested that the Fig Gardens at West Tarring, near Worthing, and the Archbishop's Palace were from the time of Thomas Becket, the archbishop executed by Henry II, but both have been proven to be from much later. My favourite error though is this literary one: the publicity team for Worthing's Lions Carnival managed to misspell 'Lions' one year, leaving us with an image of a very different type of parade...

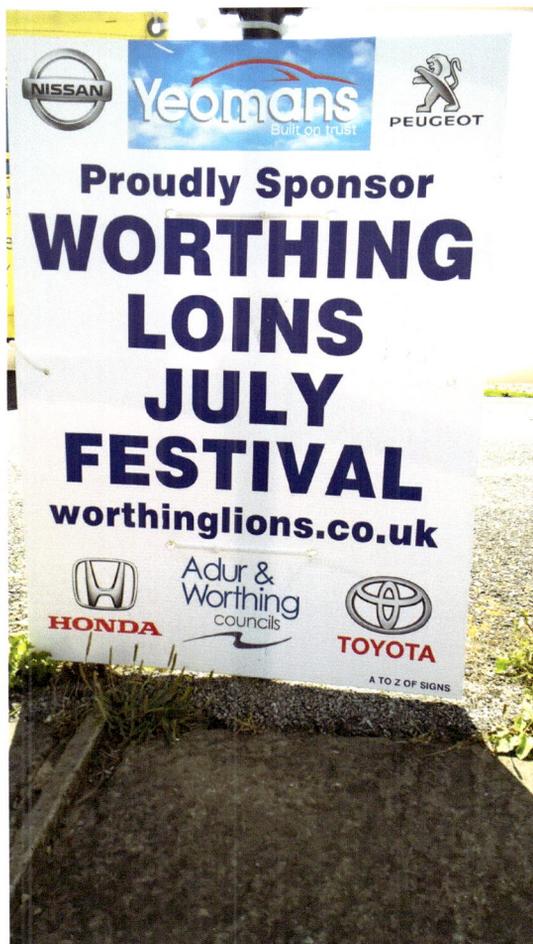

An unfortunate mistake. This advert for the Worthing Lions Festival ended up advertising an altogether very different event.

F

Fig Gardens, West Tarring

The Fig Gardens in Tarring High Street is one of Worthing's oldest visitor sites. The current trees date back to 1745, but an old myth persists that the original trees were linked to St Richard, the thirteenth-century Bishop of Chichester or even Thomas Becket, Henry II's 'turbulent priest' (1120–70). This might be because the manor of Tarring was once a peculiar (land owned by the Archbishops of Canterbury), and had been given to them in the tenth century by King Athelstan. The Fig Gardens are privately owned today, though people can view it for free every June.

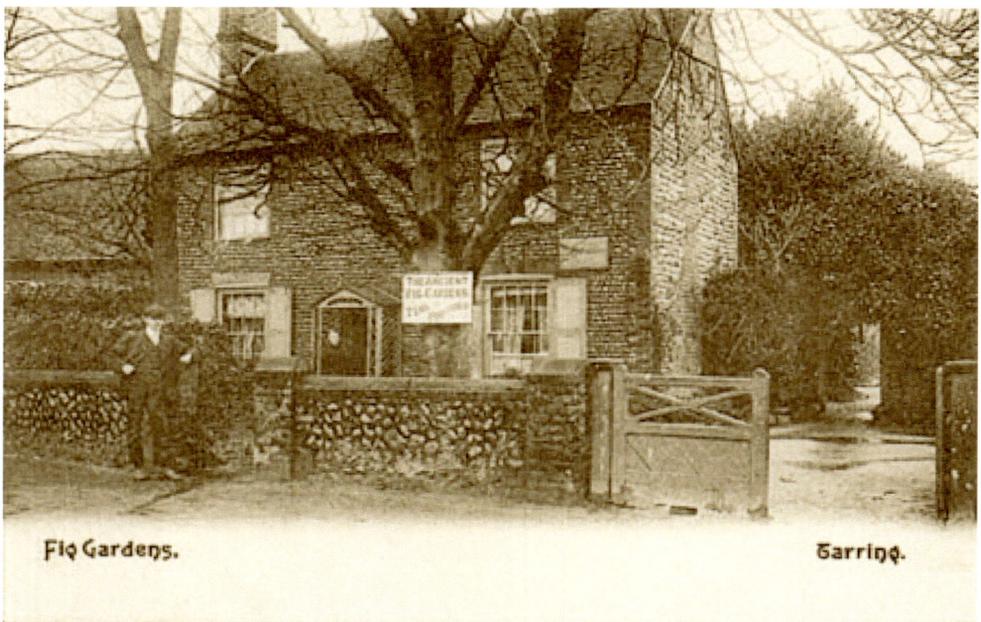

Worthing's famous and ancient Fig Gardens at West Tarring.

Film and TV

Worthing has been used for a variety of films over the years, dating back to cinema's earliest days. The very first commercial movie screening in the county took place at the Pavilion, on Worthing Pier, in 1896. Spring 1898 saw William Dickson, the 'father of film making', make seven short films here, including shooting a game of water polo in the now demolished Heene Baths in Heene Road. This makes the Worthing Swimming Club one of the first sports teams in the world to appear in a movie. Worthing continued to be used as a film location throughout the twentieth century, from *Up The Junction* with Dennis Waterman (of *The Sweeney*, *Minder* and 'Write the Theme Tune, Sing the Theme Tune' fame). In the 1980s, *Wish You Were Here* featured the Dome Cinema and other locations, and in 1998 *Men Behaving Badly*'s penultimate episode was based in the town. The twenty-first century saw Steve Coogan's film *Stan and Ollie* having its most pivotal scene shot here in the Lido, and the town's promenade has been used repeatedly for adverts including for Walker's crisps, Sainsbury's, McDonald's and Capital One. TV shows filmed here of late include *Cuffs* (BBC), *Flirty Dancing* (Channel 4), *Mother, Father, Son* (BBC), *Cheat* (ITV), *Hypothetical* (Dave) and *Perfect Ten* (BBC). Filming even continued during the Covid era, with Bill Nighy filming the Netflix show *Living* during 2021.

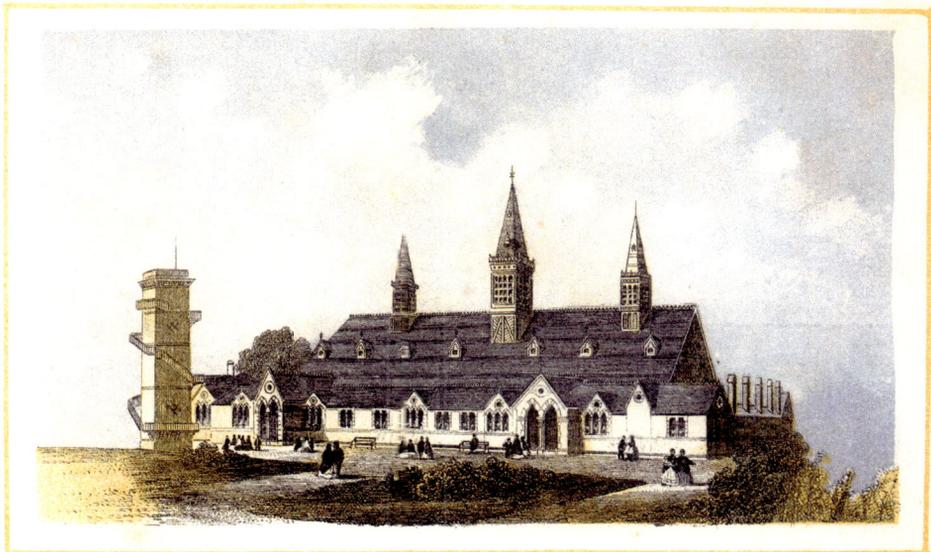

Heene Baths. (Courtesy of West Sussex Past Pictures, West Sussex County Library Service)

Football

Woodside Road is home to Worthing's largest football club, currently playing in the Isthmian League Premier Division. The Rebels, or 'Mackerel Men' as they are also known, started life as Worthing Association FC and were founded in February 1886, with matches first being mostly played in Homefield Park. The club moved to Beach House Park in 1889 and their first competition was the Sussex Senior Cup, reaching their first Senior Cup final in 1891–92 where they lost 5-3 to Brighton Hornets. They had to wait until the following year for their first victory in the final, when they won 2-1 against Eastbourne at the County Ground, Hove.

A second town team, Worthing Athletic, was founded in 1891. During the 1899–1900 season the 'Association' part of their name was dropped, becoming simply Worthing FC. This season was also exciting as Worthing entered the FA Cup and FA Amateur Cup for the first time, and Worthing and Worthing Athletic pooled resources in a merger. In 1901, the same year Brighton and Hove Albion was founded, the now well-established Worthing FC moved to the Sports Ground, today Woodside Road. The same year saw another Worthing club, Worthing Rovers, get promoted. Rovers, who were founded in 1901, also merged with Worthing FC in the summer 1905.

Worthing FC is one of Sussex's oldest football teams. The first Horsham football club was started in 1871 but wasn't officially established until 1881. Chichester's first club's history dates back to 1873. Devonshire Park, now playing as Eastbourne Town FC, was founded in 1881, the same year that Horsham FC were re-established, so are the oldest extant Sussex team. This longevity, the team's current success and its base in a major West Sussex town with a lively and family friendly stadium, all mean that it certainly deserves this spike in its fortunes, and it has room to thrive in the future. Worthing FC is one to watch – in all senses of the phrase.

Worthing United FC doesn't have quite the same historical pedigree as its more southerly neighbour of Worthing FC. Originally called Wigmore FC, the team were one of the founder members of Division Two of the Sussex County Football League for the 1952–53 season and merged in 1988 with Southdown FC to form the current team. Shorter history aside, the team does boast a more downland location, as you'd expect from the merger with Southdown FC. The Robert Albon Memorial Ground's more rural location presented a problem for the 'Mavericks' (as the club are known) though back in July 2018 when cows managed to invade the club grounds. At least they are not alone in terms of Sussex sporting venues having experienced animal invasions. Sussex County Cricket had an intrusion by sheep in its early days, attracted by the bushes growing around the ground.

G

Gardens

Worthing's public parks and gardens have a number of surprises in them. Firstly, there is Britain's only 'Warrior Bird' memorial, dedicated to the messenger birds of the Second World War who lost their lives, which can be found in Beach House Gardens along with another nearby memorial, this one to the men of Sussex who fought and lost their lives in the Battle of the Boar's Head during the First World War. We have actor Nancy Price and members of the People's Theatre in London to thank for the sculpture, which was the work of local sculptor Leslie Sharp. Work started in 1949, and the Duke and Duchess of Hamilton unveiled the memorial on 27 July 1951.

Originally the memorial was a mound covered with a rockery, which had streams flowing down into pools of water and steps that the public could climb along. There are also two boulders transported from the Forest of Dean with carved wording on them to remind us that 'a bird of the air shall carry the voice and that which hath wings shall tell the matter' (the Book of Ecclesiastes, Old Testament). Today, access has been limited, possibly as the two stone pigeon sculptures have since been stolen, but you can still read the words on a metal plaque.

Hidden underneath Brooklands Park, near the children's playground, is a former Cold War Royal Observer bunker, built to observe the destruction of Worthing as Soviet bombs dropped. On a more cheerful note, Homefield Park was much celebrated in postcards of the town. It was the first municipal park in Worthing (1880) following donations of land by Fanny Heather in 1876, Mr R. Dawes and Sir Robert Loader MP. It was the site of carnivals and local events, boasting an ornamental lake in the east end of the park formed by the damming of the Teville Stream, and a rustic footbridge perched gracefully over the water.

Sadly, around 1930 the pond was filled in as Worthing Hospital expanded to the south, but the park still has over 14 acres for locals to enjoy.

Greenhouses

Back in the 1950s, sadly one of Worthing's tomato growers took his own life as a result of his tomatoes. The 1950s were when Worthing was awash with glasshouses growing

cucumbers and particularly tomatoes, which were famed around the country. The greenhouse man ended his days by drowning himself in a water tank as he feared his latest crop of tomatoes would be a poor one.

Worthing's greenhouse tomatoes seem to have had a good reputation as Admiral Chambers, writing in 1936, added 'a Southdown saddle of mutton, a Patching truffle pie, a basket of Goring figs, a bunch of Worthing grapes and Worthing tomatoes and Downland mushrooms' to the famed list of the renowned 'seven good things of Sussex' when it comes to food. In case you're wondering what the original seven were, the first three (according to Revd Thomas Fuller in 1662) were Arundel grey mullet, Pulborough eel, Chichester lobster and Selsey cockles. Rye herring, Amberley trout and Bourne (Eastbourne) wheatear (also known as the Orlatan) were added to the list by Arthur Becket, author of *Spirit of the Downs*, nearly three centuries later. He might be pleased to know that the name of his book is now shared with a Sussex vodka. Sadly, Worthing gin has yet to inspire a literary namesake, but perhaps it will in good time.

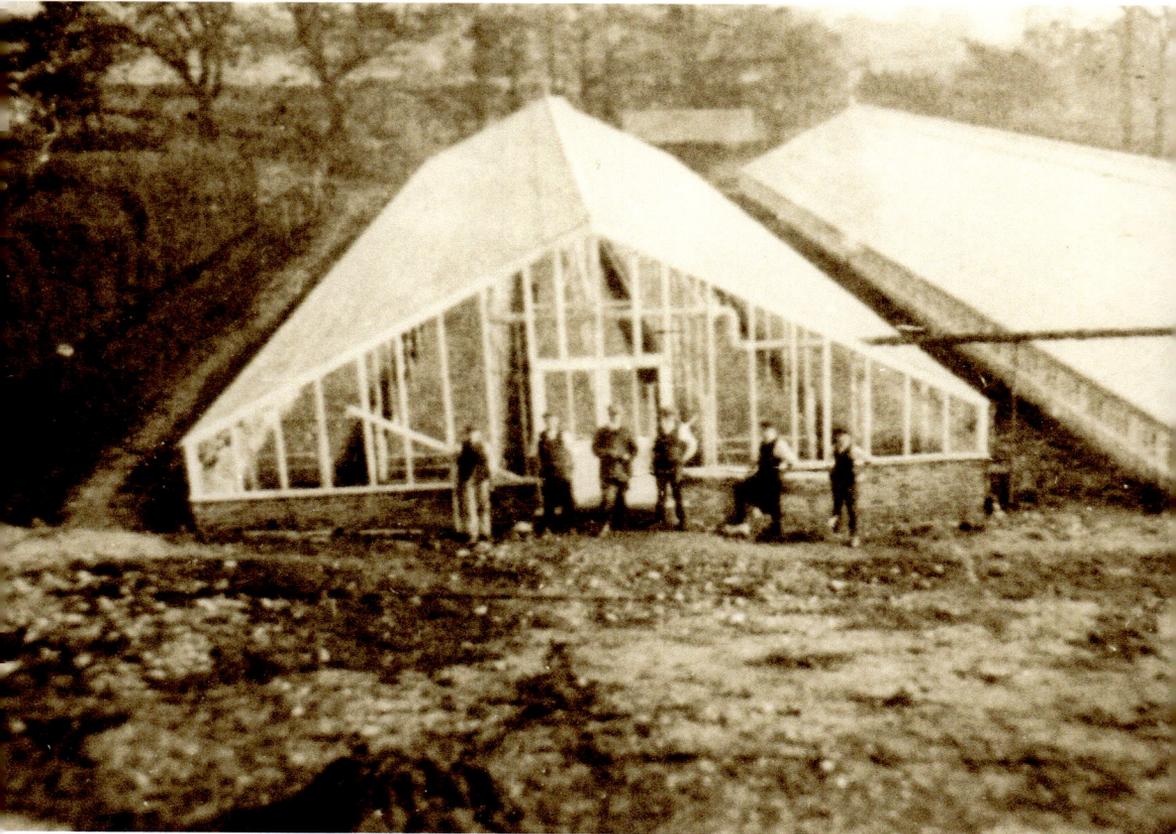

The greenhouses were once a major source of industry in the town and were the site of an unusual suicide. (Courtesy of West Sussex Past Pictures, West Sussex County Library Service)

H

Highdown House and Gardens

Highdown Hill doesn't have the most dramatic peak of the Downs, looking down in part onto the suburban sprawl and industrial development of Worthing, but it makes up for this with an incredible history and a three-in-one package of places to visit – the Hill, the House and also Highdown's gardens. Start with highest of the three, the hill at Highdown itself. It not only has views of the sea, Littlehampton, Worthing, Goring and Ferring, as you'd expect from a southern outcrop of the Downs, but it also allows you to spy upon both Cissbury and Chanctonbury from the site of another ancient hillfort. Those with good eyes and on a day with equally good weather, can see as far as the Severn Sisters to the east and the Isle of Wight to the west.

Highdown dates back to the Bronze Age. An enclosure of some sort existed around 1000 BC and was replaced 400 years later in the Iron Age by the aforementioned hillfort. It has an Anglo-Saxon cemetery dating from the fifth century AD and, most amazingly, is believed to be the ancient burial ground of Sussex kings. Almost as interesting, and a lot more recent, is that it has the final resting place of the last owner of Highdown Mill, John Olliver, further to the east. More on him later on.

Highdown House has a concrete bunker, which the former owners argue was the HQ where General Bernard Montgomery co-ordinated some of the action from for D-Day in 1944. This may not have been Highdown's first link with large battles either. Some historians believe that Aelle, leader of the fifth-century Saxon invasion, may have been buried there after a fight with none other than King Arthur. Slightly more believable is that Roundstone, tucked below the hill, gained its name from the round millstone at Olliver's Mill running downhill from Highdown above.

The gardens at Highdown are probably the most hidden of all of Worthing's gems and were created against the odds by Lloyd George's one-time private secretary, Sir Frederick Stern, and his wife Sybil Stern, who had served in the Middle East in the First World War, started a unique garden against the odds that has today been deemed a National Collection and recently had £1 million of improvements during Covid. Before his war service back in 1909 he started to use a chalk pit on the hill at Highdown to prove that plants not used to chalky soils could be encouraged to grow there. It was not until his marriage after the war in 1919 to Lady Stern that he

The Highdown.

really started to get the garden underway, however, and the two of them embarked on the challenge of making the uncompromising soil yield great results. It really was a huge challenge as there was little soil, and what was there wasn't particularly favourable to the plants they hoped to grow. Seed and plant collectors travelling abroad brought back unusual flora from as far as China and the Himalayas (often in dangerous conditions), which boosted the variety of flora. Subsequently, today it has a wonderful display of unusual plants, including the delightful 'handkerchief tree'. The best time of year to visit the gardens are spring and early summer, but it is a hidden treat at all times of the year. There are also open-air performances that take place on the lawns of the gardens, with the one-time chalk pit making a fantastic alfresco auditorium.

Finally, after your rambling and enjoyment of the sheltered gardens at Highdown, why not reward yourself with a much-deserved meal and drink at The Highdown. This venue was once Highdown Tower, formerly the property of the Bowes-Lyon family, from which the Queen Mother was from. At least six royals visited the Sterns in their home, along with David Lloyd George. This flint-faced 1820s building with stone mullions has been both a language and dancing school since its time as the house of Sir Frederick and Lady Stern, and was where they planned their magnificent garden. The hill certainly saw activity in the Second World War as it was the site of a radar station. Following a late twentieth-century spell as a nightclub, today it is a far more refined bar, restaurant and venue. For the hill, gardens and hotel, you approach and leave via a climbing access road that is lined with 'Emperor' and 'Empress' daffodils in spring – they were first planted back in 1867. A visit to Highdown may not quite be the pastime of emperors and empresses today, but it has been visited by royalty in the past and is still a great way to spend a large chunk of a day.

Homefield Park in 1892, when its lake still formed part of the park. (Courtesy of West Sussex Past Pictures, West Sussex County Library Service)

Homefield Park

Further east across Worthing is Homefield Park. Today it has been encroached upon by the expansion of Worthing Hospital (which it is north of), and the lake here, fed by the Teville Stream, has since been covered over, although the park suffered floods several years back as the water level rose again. Houses around the park also sometimes complain of damp, having been built around the valley of a small stream. Those seeking a lakeside park in Worthing today need to travel east even more to Brooklands Park, on the border with Lancing. Homefield Park does have one other past glory: it seems that Worthing Cricket Club used it as their base in their early days, back when it was known as 'the People's Park'. Today Worthing's cricketing action is centred on Broadwater.

Hotels

Early visitors to the town could stay at Sea House, the Nelson and the New Inn, but Worthing's first purpose-built hotel was the Steyne Hotel, today located at the south end of Chatsworth Hotel with Brio Italian restaurant below on the ground floor and terrace. It was built in 1807 after a large party visiting Brighton sojourned to Worthing for the day but most had to return rather than overnight in Worthing as there was no guesthouse large enough to provide food and lodgings. The grand Regency building Worthing gained as a result more than made up for its shameful earlier lack of accommodation. The hotel was later joined with a noble terrace as the neighbouring Chatsworth expanded and took over the older, sea-facing building. This building was altered in the 1860s to provide its current exterior of bay windows. TV's Chris Packham stayed there when he was filming *Who Do You Think You Are?* There was even a scene featured that was in a seafront guest room there. The Chatsworth is Worthing's most historic hotel and, according to its staff, is even home to a friendly

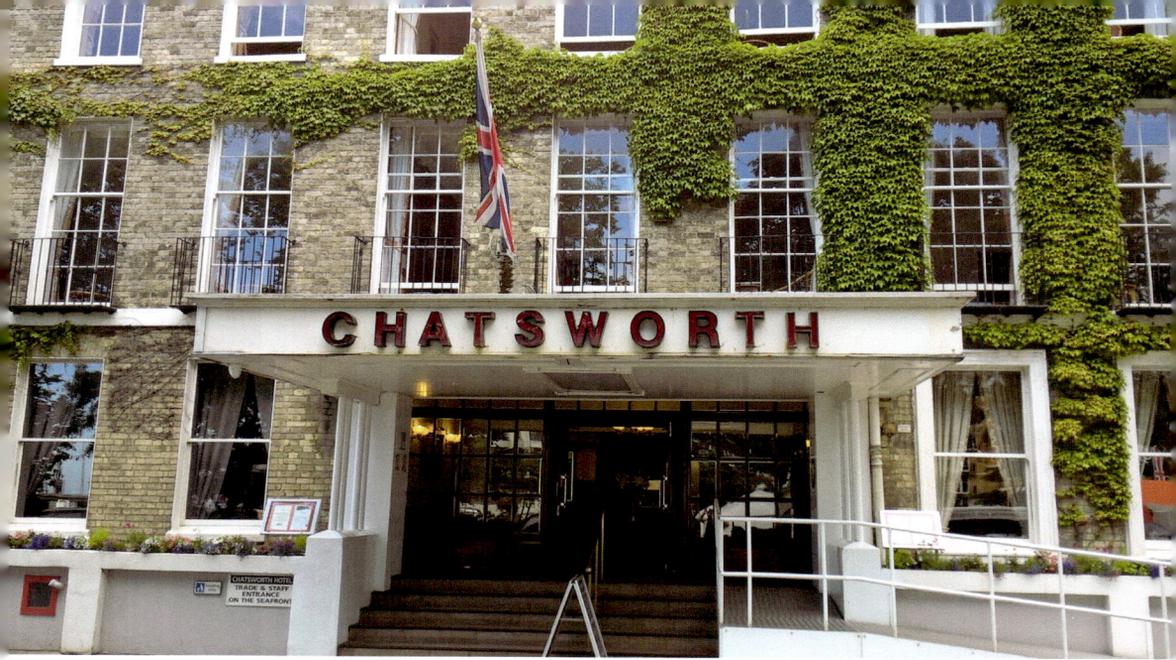

The Chatsworth Hotel's main entrance.

ghost. The Chatsworth Hotel told the *Argus* newspaper in 1997 of some less amenable visitors, though, including one who brought his car engine into his hotel room and worked on it in the bath and another who hung a squid from the hotel's chandeliers as a wedding night prank! Pranks, liveliness and frivolity were also on order when the cast from *Men Behaving Badly* stayed in Worthing. Residing at the neighbouring Ardington Hotel, the cast apparently kept up the theme of the show with late night partying.

At the other end of town is the Burlington Hotel (originally the Heene, then the West Worthing Hotel). It is part of the development that began in the 1860s with Heene Terrace, part of a planned separate town named West Worthing. Both the Heene Terrace Development and the adjacent hotel are sumptuous. The hope for many years was that West Worthing would become to Worthing as Hove is to Brighton, or St Leonards was to Hastings. This beautiful Victorian hotel on Marine Parade previously had an adjacent Winter Garden and one-time brasserie, which today is a function room and former nightclub. The Burlington survives in its original Victorian guise, although its bricks have since been given a stucco overcover, painted white and grey. Its exterior was also altered in the early twentieth century by adding a glass front, but this has not been to any detrimental effect.

In comparison to the Burlington, which has survived pretty much intact from its earliest days, there is little to show that the Esplanade Hotel once existed at the east end of town, where the Esplanade met Brighton Road. It was once the first set of buildings visitors arriving at the town from the east witnessed, and a fuller account of the story of the hotel is available in Antony Edmonds' comprehensive and very readable *Lost Buildings of Worthing*.

In some postcards of Worthing the Esplanade is recorded as being by the town's marina – 'marina' involves a bit of poetic licence, but, to be fair, some of Worthing's fishing fleet still moor on the beach there today.

The most northerly house of this L-shaped terrace was called the Haven. It later became part of the Esplanade Hotel and was borrowed by the Wilde family. It was also where Oscar Wilde and family stayed during the summer of 1894. During that summer, Wilde wrote his finest play, *The Importance of Being Earnest* in record time, enjoyed sailing, the Worthing Regatta, built sandcastles with his children and still managed to entertain Alfred Lord Douglas ('Bosie'), as well as undertake an affair with a sixteen-year-old local boy named Alphonse Conway. The relationship would later be used as part of the court case with the Marquess of Queensbury that would lead to Wilde's subsequent arrest and prison sentence in Reading Gaol. Research by Antony Edmonds for his earlier book *Oscar Wilde's Scandalous Summer*, showed that Wilde's blue plaque is on the wrong end of the building. It is at the seaward end of the 1970s block of flats that replaced the Esplanade, which was demolished by the late 1960s, whereas Wilde's accommodation was at the Brighton Road end.

Wilde's centenary in the town was celebrated, and festivals have featured the great writer and his wit, but it is sad that the town's homage to Wilde is on the site of an unpleasant-looking garage, car wash and 1970s block of flats. Surely the site where Oscar Wilde created his greatest work deserves a little more?

The site of the Haven and Esplanade today – no longer quite fitting for one of our literary geniuses.

Ice Prince, Indiana … and Sheds

As a coastal town, Worthing is used to making the most of unusual things washing up on its shore. Seaweed has been a perennial problem over the years, until local farmers started to use it to fertilise their crops. Shipwrecks and storms also provided a bounty for Worthingites at either end of the twentieth century. In March 1901, the *Indiana* shipwreck disaster off Worthing's coast led to numerous oranges and lemons being washed ashore. Locals industriously turned the fruit into a bumper crop of marmalade that year, an event commemorated annually with the 'Fruit Flingathon'. During this, local supermarket Waitrose usually supply the soiled fruit that participants throw on Worthing Beach.

In November 1926, a baby circus elephant washed up on the beach and was discovered by two fishermen. Jumbo, as locals christened the baby, has been recently commemorated by a statue by the Perch Pizza restaurant.

More recently, in January 2008, the Greek vessel *Ice Prince* lost much of its cargo when sinking off the Dorset coast. A whopping 2,000 tonnes of prime timber washed up on beaches from Ferring to Hastings, with Worthing's shore receiving the majority, causing what the BBC dubbed a 'wood slick'. Locals were warned by police not to remove any timber as it would be illegal. However, when taking a school assembly that month I decided to ask the 400-odd children whether any of their dads happened to be building a shed. Nearly every hand went up.

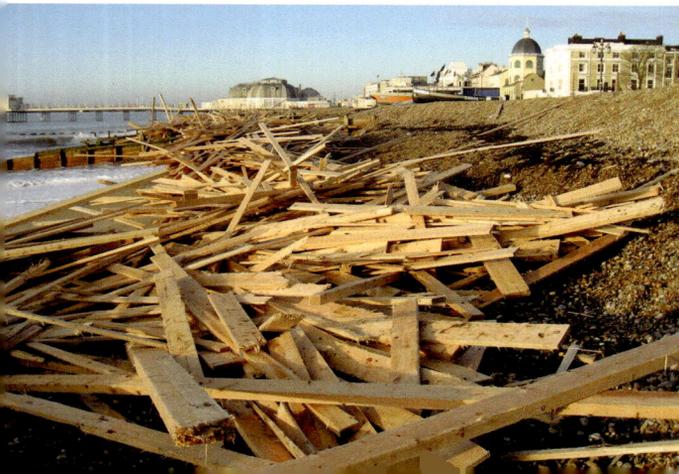

The wreckage of the *Ice Prince* on Worthing Beach in 2008. (Courtesy of West Sussex Past Pictures, West Sussex County Library Service)

Jorian Jenks and William Joyce

In 1937, Jorian Jenks, an Oxford graduate and Angmering farmer living at Ecclesden Farm, was chosen by the BUF to be its prospective parliamentary candidate for Worthing and Horsham (the constituency boundaries were different then and the town's population was smaller, compared to today when Worthing alone has two MPs). Jenks was the BUF's national advisor on agriculture, but apparently didn't join Mosley's movement. This doesn't seem to have prevented Osward Mosley from wanting him as Worthing's MP candidate. Thankfully, Jenks never got the chance to

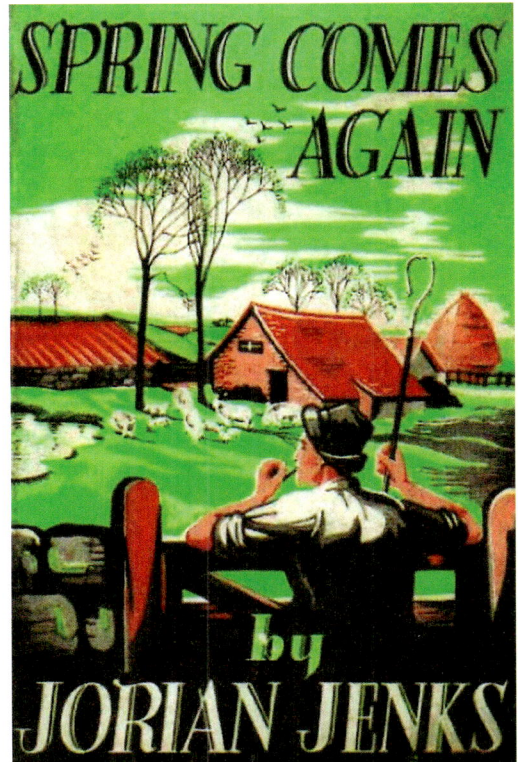

Spring Comes Again, the book by BUF member and prospective parliamentary candidate Jorian Jenks.

stand as the war in 1939 meant that the election was postponed until 1945. Jenks, like Budd and Mosley, was interred but, unlike them, not throughout the whole war. Jenks wrote a book on agricultural ideas in 1939 called *Spring Comes Again*. He worked as an advisor to Mosley after the war and remained monitored by MI5. He seems to have emigrated, as did fellow fascist Captain Budd. Worthing's one-time prospective fascist MP died at the age of sixty-four in 1963.

Another BUF parliamentary candidate for Worthing was William Joyce, who was the most anti-Semitic of all the organisation's leadership. Between April 1934 and 1937, when Mosley reduced the size of the party and fired him, Joyce served as Area Administrative Officer for the BUF's West Sussex division. In 1939 he emigrated to Nazi Germany, joined the NSDAP and became known as the infamous 'Lord Haw-Haw', sending anti-British propaganda to Britain from Germany in his 'Germany Calling' broadcasts. On 3 January 1946 Joyce was hanged for treason. As a result, Worthing's one-time potential candidate for Parliament became the last ever Briton (he had a British passport although was of US-Irish heritage) to be executed for high treason and the penultimate person to be executed for a crime other than murder in the UK.

K

Knoblock, Edward

Despite sounding like a Bond villain or a painful groin injury, Edward Knoblock (1874–1945) was in fact a famous novelist, playwright and socialite who owned and restored Worthing's Beach House between 1917 and 1923 following its ownership by the Loder family. Born Edward Gustav Knoblauch in America, and following a childhood in Germany, Knoblock anglicised his name after gaining British citizenship and a post as a captain in the British Army in the First World War, as well as being recruited to MI6. Most famous for his play *Kismet*, Knoblock was a prolific playwright who also co-dramatised *The Good Companions* in 1931. Ironically, Knoblock wasn't seen as a particularly good companion due to being dreary company, that is if a story about gaffe-prone actor John Gielgud is to believed (Gielgud insisted it was true). After a fellow diner at the Ivy walked past their table, Guilgud stated: 'Thank God he didn't stop, he's a bigger bore than Eddie Knoblock', forgetting who he was dining with.

Beach House, once home of Edward Knoblock, playwright and novelist who, yes, actually chose that surname.

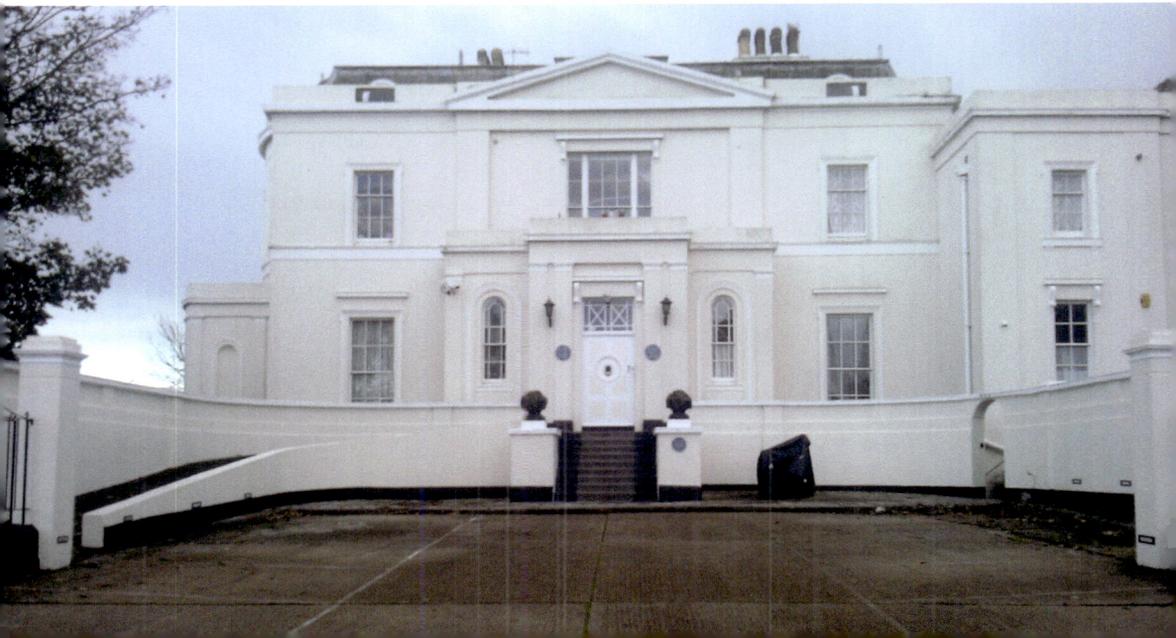

Lost Visions for Worthing

Worthing was due to have a second (west) pier and a huge Hotel Metropole to rival Brighton's, as well as two major roads heading to the seafront. The huge hotel development commenced in 1893 with an east-facing wing built in Grand Avenue. A further south-facing main wing seems to have been planned, as the construction was incomplete at the south end. Having a less desirable east-facing development when the surrounding area in the west of Worthing was undeveloped seems bizarre too – sea-facing rooms would have commanded a far higher price. Planning permission that had been granted for 370 beds also suggested a south wing was due to follow, as 370 beds would have been far bigger than the completed east wing alone.

The Metropole was designed to complement a planned West Worthing Pier at the end of Grand Avenue, but that also never materialised. There are clues today of these plans: steps on the promenade and the start of a grand entrance. The hotel, which wasn't part of the same chain that owned Metropoles in Brighton, London, Monte Carlo and Canne, was built in a similar curvaceous style to the one at Folkestone, which was decorated with Dutch gables. Financial collapse meant that the envisaged hotel remained a shell for thirty years, and though despite plans for a 'Hotel Majestic' were also proposed, these too fizzled out. The east wing was eventually completed as 'Grand Avenue Mansions' and then known as 'The Towers' complex of flats when completed in 1923 (possibly due to the planned towers that had been on the aborted southern wing). It has been known as Dolphin Lodge since its renaming in 1972 following the addition of a completed southern end, which is in a style very much of that era but incongruous with the original 1890s building.

Dolphin Lodge today is worth a visit as a unique Worthing and Sussex building architecturally, but also perhaps as one of Sussex's most unlucky buildings. Hopefully in some alternate reality there is a bustling Worthing Metropole at the centre of the successful seaside resort of West Worthing, complete with adjacent pier and numerous holidaymakers. Worthing could have even started to rival Brighton as a conference resort, as it would have had a huge luxury hotel with an exclusive name. Sadly, the town never built a hotel on that scale and the area has ended up, according to Antony Edmonds in his *Lost Buildings of Worthing*, as our very own 'Bucharest-on-Sea'. In

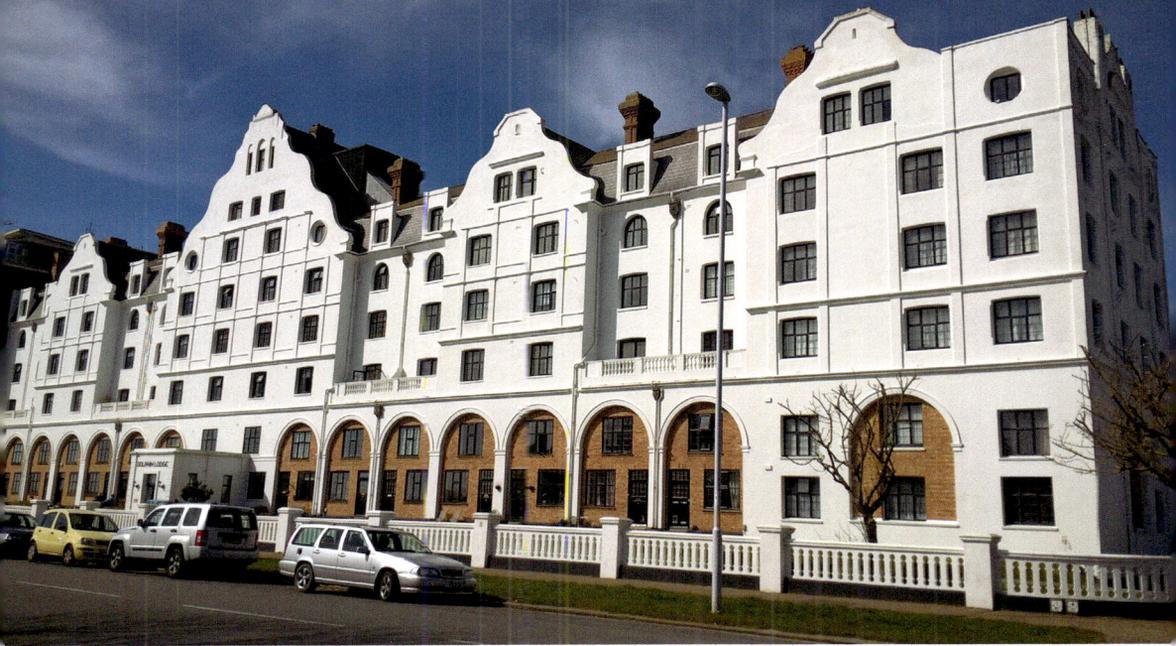

Dolphin Lodge, the name for the complex of flats that, in an alternate universe somewhere is a thriving Worthing Hotel Metropole.

one way, at least Dolphin Lodge is an exercise in efficiency. A lot of hotels ended up being converted into flats after a spell as a hotel, like Folkestone's Metropole. But Worthing's Metropole, after a spell as an empty shell, went straight to that state and missed out on the time as a hotel altogether.

M

Mary (and Her Little Lamb)

Broadwater Cemetery may record dates of deaths, and even some murders, on its tombstones, but it also contains the record of a life that has bought much happiness to countless young children. Mary Hughes, who lived in West Tarring (today part of Worthing), died in 1931. As a young girl, Mary lived in North Wales, where a poet called Miss Buel visited her parents' farm from London. Miss Buel wrote on her return an account of the funny incident she had heard, and of Mary's devotion to her lambs, some of which she'd care for if their mothers died. It was one of the lambs – Billy, in Mary's care – who caused the nursery rhyme 'Mary Had a Little Lamb' to be written. Billy, the little lamb, did indeed decide that it would 'surely go' if not everywhere Mary went, then at least to her school with her. Billy followed her all the way on her long walk to school and caused merry havoc by running around Mary's classroom until the stern schoolteacher firmly gave Billy's school day the chop.

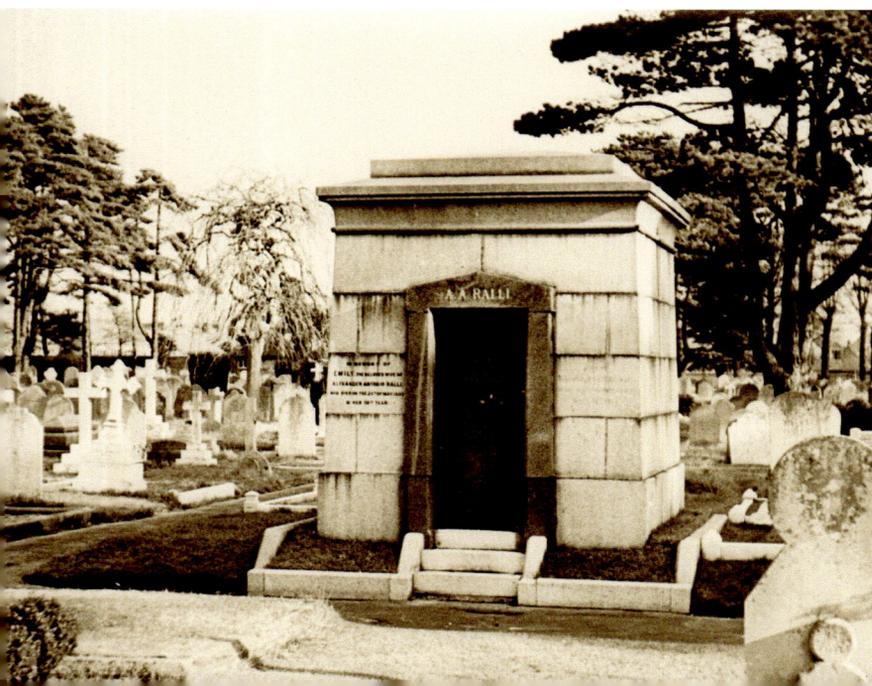

Broadwater Cemetery, c. 1944, resting place of the inspiration behind a famous nursery rhyme. (Courtesy of West Sussex Past Pictures, West Sussex County Library Service)

Mayors

Although Edward Ogle, as the leading commissioner of early Worthing, acted in a capacity similar in some ways to a mayor today, it was Alderman Alfred Cortis (1833–1912) who became the town's first official mayor in 1890. The town's first female mayor was Mrs Ellen Chapman JP in 1920–22, who had been its first female councillor in 1910 – eight years before some women were given the vote. Chapman, a suffragist, would have been mayor in 1914 but faced a barrage of 'controversy, opposition and threats in the council' (according to Elleray), which prevented her taking up the post. Another JP who became mayor was Charles Bertram Barber, who had a background in the Post Office Workers' Union and the Labour Party, making him Worthing's only Labour mayor to date, taking up the post in 1936.

Above left: Ellen Chapman, *c.* 1910, Worthing's first female mayor. She could have been mayor much earlier, but the First World War prevented her taking the post. (Courtesy of West Sussex Past Pictures, West Sussex County Library Service)

Above right: Alderman Alfred Cortis, *c.* 1902, Worthing's first mayor. (Courtesy of West Sussex Past Pictures, West Sussex County Library Service)

Men Behaving Badly

Back in 2018 the town held the first – to be honest, only – Badlyfest, which took place in Worthing's Dome and celebrated twenty years since the penultimate episode of the hit 1990s sitcom *Men Behaving Badly,* 'Gary in Love', being filmed in the town. The evening included a showing of the episode in question, food, drinks and a Q&A with series creator and Sussex-born TV writer Simon Nye. The 'hotel' used in the show (actually the Eardley training and conference centre, since replaced by the Eardley building) has the best Carry On-style seaside joke used on British television since the end of that film series: it was called Groyne View. Splash Point, the part of Worthing Promenade facing the Eardley, was turned into a crazy golf course for the show but is today an impressive work of art with a button where visitors can turn on underground water fountains (when working). The show highlights how in the 1990s the seafront looked very different east of the Steyne, having no Warnes building and no new Eardley building.

The show included Martin Clunes and Neil Morrissey perched atop the former entrance to Worthing Pier after going on a bender on Worthing Beach. They end up stealing 'Wetfish Willie', a massive plastic fishy guardian to the pier that was created

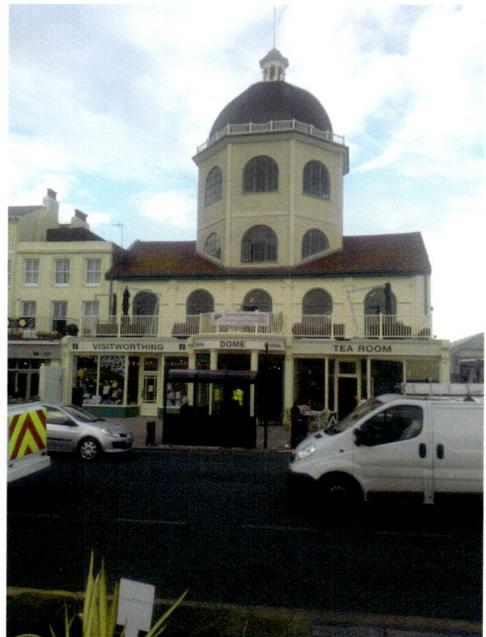

Above left: Simon Nye, Sussex's own and creator of numerous TV shows including *Men Behaving Badly.*

Above right: The Dome, an apt location to host 2018's Badlyfest event as the building featured several times in the 1998 episode 'Gary in Love'.

The Eardley today. The twenty-first-century rebuilding of the former Eardley is very similar to its earlier namesake.

specially for the show. The result of the men 'behaving badly' was that it ended up in their hotel room before being set free using helium balloons above the Balcombe Viaduct, in the style of the house in the film *Up*. The fishy prop ended up in the Beach Office's stores for many years before sadly being recycled by the council.

The Eardley Conference Centre in 1998, aka 'Groyne View Hotel' for the show. (Courtesy of Hartswood Films)

N

Names

What is now Worthing is a conurbation of what was once a collection of villages and an area comprising of two manors in the Domesday Book – Ordinges and Mordinges. Nobody is exactly sure how these names (or perhaps just one) had morphed into Worthing by 1297, but the town is recorded as Wuroininege in 1183, Wurdingg in 1218, Wording or Wurthing in 1240, Worthinges in 1288 and Wyrthyng in 1397. Worthen was used as late as 1720, but the earliest mention is 'Weoroingas' in Old English. The usual practice for Saxon place names was to title the settlement after the leading Saxon tribal chief – presumably here Worth/Weorð/Worō. As such, with 'ing' or 'inga' as a suffix, Worthing means 'the place of Weortha's people'. However, the Domesday spelling of two manors here, both without the 'w', has put this into doubt. Perhaps the Norman investigators for the Domesday Book misheard. Or, if 'Ordinges' was the accepted early pronunciation, and as the Normans placed Worthing mostly within Bramber Rape, the Norman overlord of which being William de Braose, perhaps it is an abbreviation of 'William's Ordinges'. It is a shame though there seems to have been no historical record of a Saxon chief named Weorð, Worō or Weortha, especially as in the case of the latter the good folk of Worthing could have referred to themselves as 'Weortha's originals'.

Worthing had a strange run of pig-related surnames in the early 1800s. There was a Mrs Hogshead and Mrs Bacon running the town's two leading seafront hostelries, the Sea House Hotel and the New Inn. Unbelievably, one of the town's leading businessmen and the owner of the town's theatre at this time was named Mr Trotter! His first name though was Thomas, not Derek.

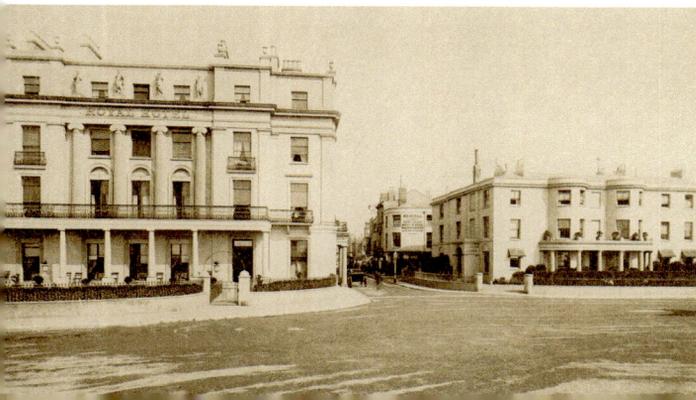

The Royal Sea House Hotel/ Royal Hotel (left) and The Marine Hotel/New Inn (right). In the nineteenth century these were the locations of Mrs Hoghead and Bacon, whose names even inspired a play to be written about them. (Courtesy of West Sussex Past Pictures, West Sussex County Library Service)

Old Town Hall

O

Worthing's much-missed old Town Hall was located where the front concourse and steps of the Guildbourne Shopping Centre are today, built in 1969–70. Never has the construction of one development in Worthing been responsible for the loss of so many historic buildings. The demolition of the Town Hall predates this, however. In fact, it only stood 130 years, from its construction in 1835 to its end in 1966. By the end of its lifespan it had been made obsolete by the new 1930s Town Hall in Chapel Road, suffered from structural weaknesses and was seen as too small to be worth keeping. It is a real shame as it comprised police cells, a courthouse, bank, the garage for the town's fire engine and a hall that both suffragettes and the British National Party had held talks at. Local election results were announced from the building's steps. Today

The site where Worthing's Old Town Hall once sat. Today it is home to a clock tower, some flower beds and steps covered in pigeon excrement.

Chapel Road, the road heading south down from the site of the Old Town Hall to Worthing Pier.

the building would have made a great community centre or pub, and would mean the town had retained one of its most important buildings. Alas.

Olliver, John

Highdown Hill, near Worthing, has lots of reasons to visit, but the most interesting reason is that it is the final resting place of Highdown Mill's last owner, John Olliver. Olliver was known as the 'Mad Miller' due to his eccentric tendencies, but, judging by the thousands that turned up to his funeral, he was also a greatly appreciated local figure. Perhaps, though, the number of attendees were down to the local populace being informed long in advance that it would be happening. Olliver had built his tomb twenty-seven years before his death in 1793, not due to hypochondria or extreme forward planning, but more likely as it was a storage place for his share of the smuggled goods he helped move further north to wealthy London markets. Some of these would also find their way into the homes of struggling Sussex families, so no doubt Olliver ensured the survival of some hard-up Sussex folk.

He was a smuggler with style too. Reputedly, he would set the blades of his mill at pre-agreed angles to inform smugglers at sea whether the customs men were in the vicinity. He was also apparently a talented puppeteer and made a smugglers' version of *Punch and Judy*. Punch was a customs official and Judy an old lady who would proceed to bash the customs official over the head. Olliver's head is also of interest, as he apparently had it pointing downwards when buried, along with the rest of his body, so that on Judgement Day he would meet his maker quicker, according to local legend. The mill has long since been demolished, along with Olliver's cottage, but his tomb thankfully still remains in this glorious stretch of National Trust-owned downland.

P

Park Crescent

This semi-crescent of houses designed by Amon Henry Wilds surrounding Amelia Park is a worthy visit for fans of Regency architecture or of the Wilds and Busby firm of architects. Originally named Royal Park Crescent, this is the only development that both Wilds and Busby built in the town, and it echoes their later Park Crescent built at the north end of what is now Brighton's The Level park and the Montpelier Crescent development, also in Brighton. It is even more unusual as it is incomplete: it was planned to be a full crescent, but funding became a problem in the turbulent economic times of the early 1830s. Building, which commenced in 1831, ceased promptly in 1833. The Brewhouse and Kitchen (formerly the Beechwood Hall Hotel and originally the Swiss Cottages) are at the south-western end of the unfinished development. Montpelier Crescent looked towards the Downs from Brighton when first built, and Park Crescent in Brighton down to St Peter's Church, but on the same altitude as more southerly developments in Worthing, it is unclear what Wilds was hoping the end effect of Worthing's Park Crescent would be. It is strange he didn't try to recreate his father's Kemp Town, or Brunswick in Brighton and Hove, along the much emptier seafront at Worthing, but instead made somewhere with an obstructed sea view. Nevertheless, Worthing's Park Crescent is a rare architectural gem and a good example of Italianate building from Brighton's premiere architectural partnership.

The entrance to Park Crescent. The park in question was renamed Amelia Park in honour of Worthing's first royal visitor and is now open to the public and not just residents, as was the case when the development was first built.

Park Crescent today. It is interesting to imagine how a completed Park Crescent would have looked and also to compare it with another Amon Henry Wilds construction, Park Crescent in Brighton.

Piers

Sussex has lots of wonderful piers, but Worthing's one is a true survivor and has thrived in recent years. Built by Sir Robert Rawlinson, when it opened on 12 April 1862 it was only 15 feet wide and 960 feet long. It is well known locally for having 'blown down, burnt down and been blown up': in 1913 strong gales caused decking between the pier and shore to be washed away; 1933 saw a fire destroy the South Pavilion; and in 1940 a hole was blown in the pier's decking to stop it being used as a landing point for an enemy attack. Today it is now truly on the up, and was awarded 'Pier of the Year' in 2006 and 2019. It usually perches near the top of the National Piers Society's 'Pier of the Year' list, and has even been described by the *Sunday Times* as being 'peerless'. Its crowning moment on the small screen was when it featured heavily in *Men Behaving Badly* back in 1998. Its other claims to fame include being the backdrop of a Will Young music video; featuring on the cover of *To See the Lights*, an album by 1990s indie band Gene; and, of course, being the site of the 'Birdman' competition instead of, and alongside, Bognor for a few years. The land end of the pier holds a busy mix of venues, such as the successful Pavilion Theatre and the 1950s art deco Denton/Pavilion Café, which has some of the best views in Worthing, including of the Birdman when it took place. There are two features on its pierhead that make it unusual: a successful sea-end venue in the Southern Pavilion (the Perch on Worthing Pier) and a landing stage for fishing and disembarking passengers of the *Waverley* pleasure craft, just as it once did for the *Balmoral* and the *Worthing Belle*. Technically, though, Worthing could be classed as having two piers – one more than Brighton. The NPS (National Piers Society) say a pier qualifies as such when it has metal legs that are touched by salt water at high tide. Going by this, could Worthing's Lido technically be its west pier?

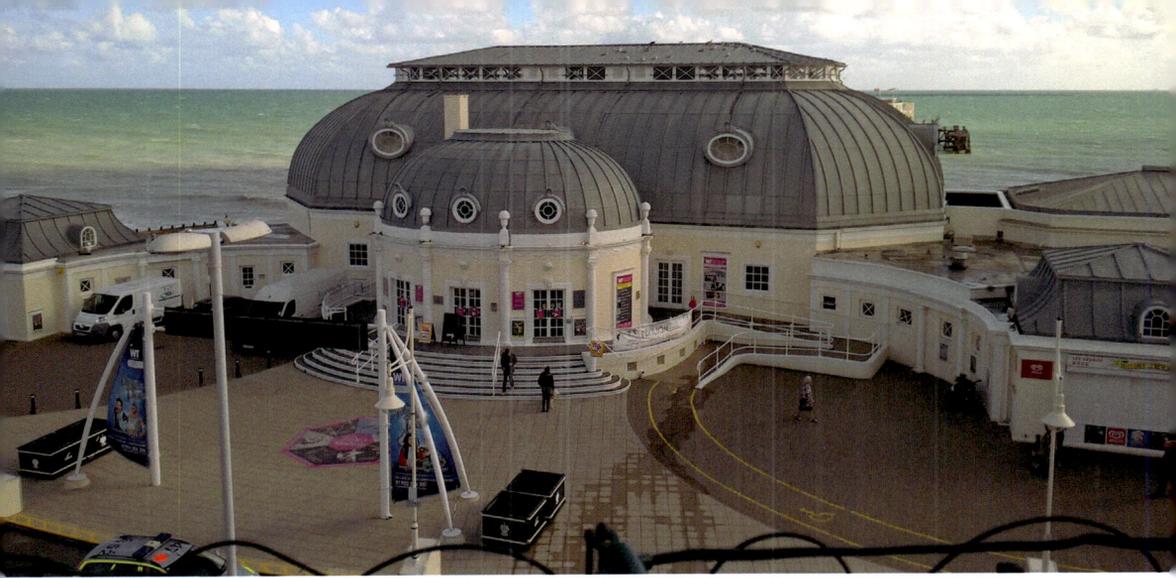

Above: Worthing Pier's Pavilion Theatre.

Below: Worthing Pier when first built in 1862. (Courtesy of West Sussex Past Pictures, West Sussex County Library Service)

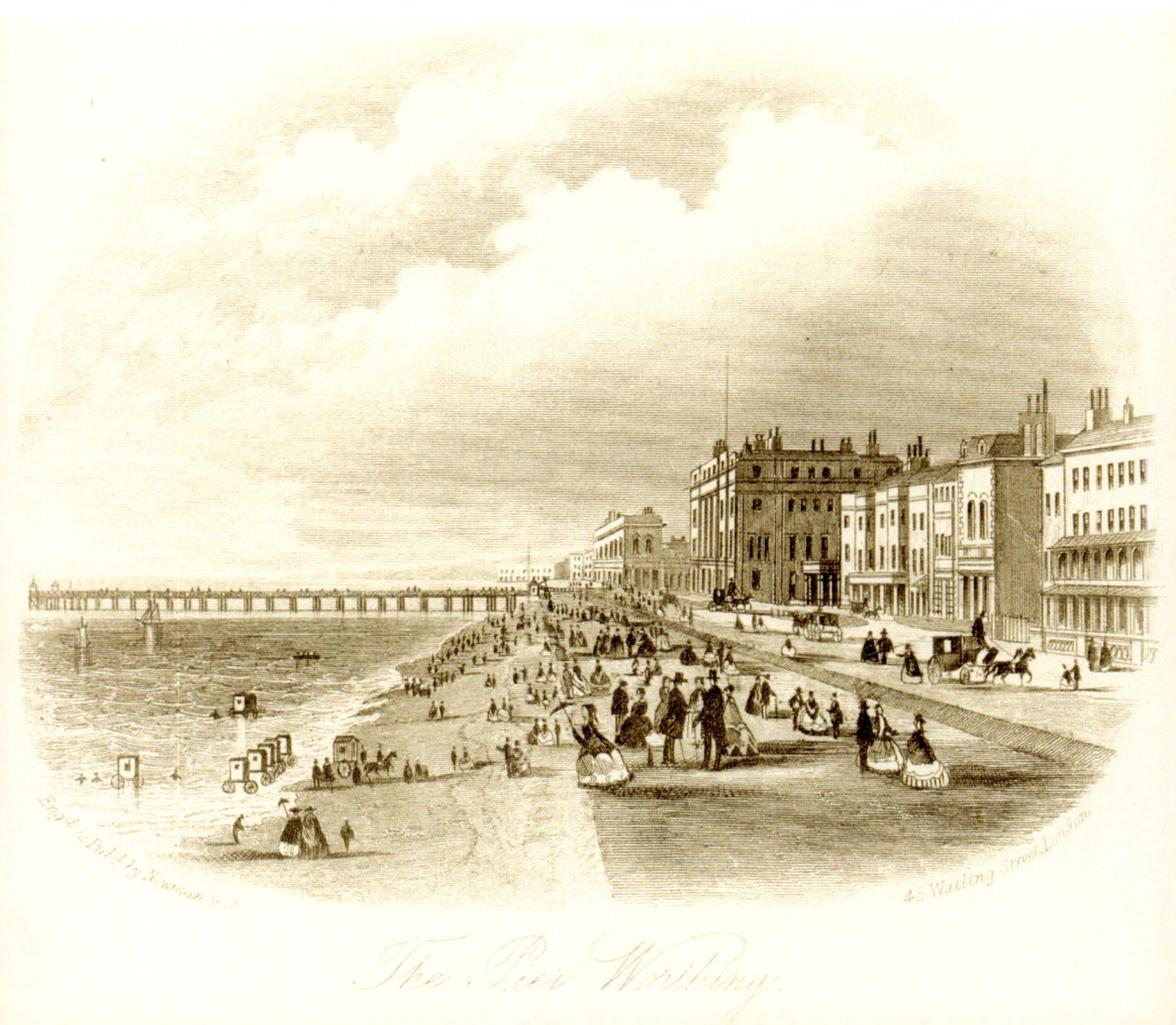

Worthing Pier has been awarded Pier of the Year twice this century and was visited by Disraeli in the late 1800s.

Prime Ministers

Sir Winston Churchill (1874–1965) visited Worthing, firstly staying at Warne's Hotel during the Second World War and then a second time in October 1958. He attended a performance of *Variations on a Theme* by Terrence Rattigan with Lady Clementine Churchill which their daughter was appearing in. Fellow author and PM Benjamin Disraeli (1804–81) stayed at Worthing's Marine Hotel at some point, believed to be between 1868 and 1872, with his wife Lady Beaconsfield according to Revd Frederick Arnold, as reported in Antony Edmonds' *Lost Buildings of Worthing*. Disraeli, who seems to have been recuperating at the time, kept himself to himself according to Arnold, but the couple enjoyed a visit to the pier opposite at dinner time.

The Warnes building, which replaced the hotel of the same name which Churchill stayed in during the Second World War.

Q

Quirky Worthing

Several world records have been set in Worthing, including the heaviest fig grown – 295 g by Lloyd Cole on 28 August 2015. Worthing is also the site of the record for the greatest number of gallstones removed from one person: in August 1987, 23,530 gallstones were removed from an eighty-five-year-old woman at Worthing Hospital who had complained of severe abdominal pain. Slightly less painful are the world's longest football marathon and the most consecutive rounds of kickboxing according to local estate agent Robert Luff, who themselves organised an attempt in 2013 to break the world record for biggest gathering of 'elves' in one place (apart from the North Pole, obviously). A total of 1,276 participants were counted, each of whom were given elf hats and ears and had to wear red or green tops. It beat the previous record by more than 500. The town centre was chosen as a site spacious enough for such a gathering; other sites provoked concerns about elf and safety...

Worthing Hospital, *c.* 1890. Later on, the hospital here would be the place of a (painful) Guinness world record. (Courtesy of West Sussex Past Pictures, West Sussex County Library Service)

R

Refugees

Worthing has often helped those in need. In 1936 the Spanish Civil War led to refugee Basque children being sheltered in High Salvington, Shakespeare Road and Beach House. The children were also accommodated at No. 72 Canterbury Road, where in May 1936, with Jewish refugee children also in the building, the walls were sadly daubed with the words 'Jews get out' and 'Britons before aliens'.

Thankfully there were many good people in Worthing at this time. One of them was Joan Strange, who was truly loved by refugees for the help she gave them. One of the hostels set up by this remarkable woman had Walter Neumann and Otto Reimer among its first lodgers. Walter and Otto were both Jews whose non-Jewish wives had accepted the doctrines of Nazi Germany and divorced their husbands. As *Storm Tide* explains, Frau Neumann had not only divorced her husband, but later caused the arrest, internment and execution of her ex-husband's family.

One of the Jewish refugee girls lodging in Church Walk was to find out that her father had perished at Dachau that August. Another girl who lodged at Church Walk was Rena Lewinnek, who came to Worthing after a long journey starting with the Kindertransport. She was ten when she arrived in England on 4 June. At the end of the

Spanish Basque children arriving in Worthing. (Courtesy of JP)

Czech refugee Paul Czerny with Worthing lady Joan Tennant. Paul was the only member of his family to survive the Holocaust. (Courtesy of National World)

Come and share my luck with me at WORTHING.

On first glance this postcard seems to advertise the Nazis in Worthing, but it actually predates this dark episode in the town's history. Before its adoption by Hitler the swastika was seen as a good luck charm, along with the others on the postcard.

war she tragically discovered her entire family, except one uncle, had been killed. Her story can be found on pp. 275–77 of *Storm Tide* and is worth reading. The experience of Paul Czerny, a Czechoslovakian Jew who ended up residing in Worthing, was even worse: he was the sole member of his family to survive the Holocaust.

The Holocaust ended with the liberation of the death camps, but its horrific legacy still lives on today, though the final few survivors who provide talks are small in number. It is now increasingly their children who are continuing talks to Worthing schools. The Angmering School has gone even further, holding Holocaust study days for its children. A number of Worthing schools continue to visit key locations such as Belsen, Saschenhausen and Auschwitz-Birkenau with the aim that these events are not forgotten by current and future generations and that such horrific occurrences never happen again.

Robeson, Paul

Paul Robeson (1898–1976), the singer, movie star and political activist was also someone who faced bigotry and hatred. An African American, Robeson faced racism on both sides of the Atlantic. He was persecuted by the US government for his beliefs, but still became a leading actor between the 1930s and 1950s, with a voice celebrated

still today by appreciative bands such as the Manic Street Preachers. He was an internationally celebrated household name in the US and Europe in the 1930s.

Singing, acting and political activism were later achievements in a full and inspiring life that saw Robeson overcome many hurdles. The son of a former slave, Paul Robeson rose to become not only a champion athlete, but a Phi Beta Kappa student and champion of racial equality. Yet despite his courage and many accomplishments, he was forced to live his last years in internal exile under FBI surveillance, a broken man who could not overcome the combined effects of racism and McCarthyism after his visit to Russia in 1939 and membership of the Communist Party.

It is good to know then that this great man had some respite and happiness due to Worthing. Robeson wasn't a permanent resident in Worthing as such, but the truth is just as interesting. He seems to have had a very close relationship with a woman called Yolande Olive ('Olivia') Jackson; she lived in Worthing, so he visited here many times. Indeed, it seems that marriage was contemplated and Robeson almost left his wife for this upper-class Worthing Englishwoman, described as very tall and blonde. Robeson also performed on Worthing Pier in 1939. At the last minute though Jackson lost her nerve and fled, marrying a white Russian prince on the rebound. Linda Grant, writer of the play *Paul and Yolande*, explained in an interview to *The Guardian* that she heard the voice of her father telling her what 'marriage to Paul would do their social standing in Worthing'. Robeson's wife wrote: 'It would be too risky an experiment [for Yolande] to give up all her friends and stupid social life to marry Paul.' She, Yolande and Robeson all lost out, and Yolande's marriage to Prince Chervachidze followed, along with rumours that a child she had with Robeson had died.

We do not know where Jackson and Robeson met in 1930, but we do know that it was when he came to London to play Othello at the height of his fame. He had a young son at the time. Grant, in her feature in *The Guardian*, explains that this Worthing high-society woman saw what began as just another of Robeson's affairs turn into 'a consuming passion'. In later years Robeson looked back on Jackson as the love of his life, 'a free spirit, a bright loving wonderful woman'.

Jackson's marriage to the Russian prince did not last long, but letters from Robeson endured. They even met once more, but there is no record of whether it was in 1939 when he performed on Worthing Pier. Grant tells how she remained in love with him, wanting him, 'weary unto death', as she wrote in 1950. According to friends, he came close to killing himself over her betrayal, but quickly got over it and many more affairs followed, as well as his long struggle with the US government and the famous case over his passport.

Regardless of their flaws the relationship is a fascinating and even daring one, in view of America's racial attitudes at the time. Had the couple tied the knot, we might have had one of the world's most famous marriages of the 1930s; the couple may even have resided in Worthing. It is interesting to speculate whether an interracial marriage at this time and of this profile could have furthered civil rights that bit sooner. Either way, it remains an interesting love story and we should be honoured that such a talented man spent time here in Worthing in the 1930s.

S

Sayer, Leo

The pint-sized poppet of pop who was born in nearby Shoreham in 1948 and is today a naturalised Australian citizen, immortalised Worthing in his song 'Moonlighting' when he mentioned Montague Street:

> They're gonna make it together
> His blue Morris van is parked in an alley
> Just by Montague Street
> His friend Eddie he did the re-spray
> So he couldn't drive it all last week.

Montague Street, which features in
Leo Sayer's song 'Moonlighting', written by
Sayer and Frank Farrel (1975).

Shelleys, The

Sussex was the home of the illustrious and literary Shelley family. Poet Percy Bysshe Shelley was born in Field Place, Horsham, and the family had the amazing Castle Goring built for the poet and his wife, Mary Shelley of *Frankenstein* fame. Shelley had some of his works printed in Warwick Street. His relative Sir Timothy Shelley owned the land that is now Chapel Road in the centre of Worthing, and allowed it to be sold so that the town could be developed. It is perhaps fitting then that the former Wetherspoons in Chapel Road was called the Sir Timothy Shelley. The former Shelley Hotel on the corner of Crescent Road and Shelley Road has recently been refurbished into apartments, but for many years the Victorian building was occupied by squatters. It regularly featured on Worthing's Spooky Tour due to its Bates Motel-esque look, the inability for light to permeate through to the building, and its links to this amazing but definitely spooky local family.

The former Shelley Hotel, back in the 2010s. Today it is refurbished flats but still a key part of 'Spooky Worthing'.

The former Shelley Hotel today, its sign still visible.

Smugglers

Sussex was one of the busiest places on the south coast for smuggling in the heyday of the criminal activity. The large amount of contraband being brought ashore made those involved very confident that they could get away with their nocturnal affairs, so they carried on their activities right under the preventive men's noses. Up the road in Brighton the smugglers would be at work in the tunnels under the Old Ship Hotel, where the town's commissioners (who would be the leading town councillors today) were meeting directly above. They would have been very embarrassed about the activity below, but not as much as the customs officials, who worked in Worthing at Cobble House in Warwick Place. Cobble House was a customs house, designed to stop those involved with smuggling. One of the town's smugglers' tunnels was said to have gone straight underneath! Worthing is said to have also had another smugglers' tunnel: from the now demolished George Inn in Market Street, which is where the Guildbourne Centre is now. Both tunnels may even have been used when the smugglers landed a particularly big cargo, and that was certainly the case with the very brazen raids of the early nineteenth century.

The smugglers increasingly became more and more ambitious, until a raid in 1832 ended with the violent death of chief smuggler William Cowerson. Cowerson was a stonemason who is said to have hidden some contraband in the tombs he worked on in Tarring's church graveyard. On 21 February 1832, he used the church spire to signal to an approaching delivery that his gang of smugglers would intercept the beach landing that night. Cowerson was the leader of such a large smuggling gang that by 1832 revenue officers in the area could only watch as goods were landed, protected by numerous 'staffmen', ruffians whose prime job was to dish out concussion to any

Warwick Place, rumoured site of a smugglers' tunnel under a customs house.

king's man who dared to intervene. The smugglers had clearly got too cocky after other successful landings, though, daring to land at the Steyne. Customs men signalled for back up, which swiftly came. The gang scattered as they used the twittens of Worthing to escape. Local folk who lived in wealthy Warwick Street were even said to have let the smugglers in through their front doors and out the back, confusing the revenue men giving chase and showing that it was not only the poor who had interest in low-priced smuggled goods. The gang ended up at the gate over Teville Stream, at the top of what is now the High Street, which the town commissioners had locked to stop vagabonds and other undesirables from entering. It now had the opposite effect, and the smugglers could only escape to Findon or Broadwater one at a time.

Worthing's Steyne today. Worthing and Bognor both spell their ground of this name with a 'y' whereas Brighton's 'Old Steine' uses an 'i'.

Cowerson used his famously large frame to block the small bridge to the gate while his men escaped. One of the leading revenue men, Lieutenant Henderson, had his arm broken by Cowerson, but still managed to fire at the smuggler at point blank range, killing him. Cowerson's funeral and burial in Steyning was attended by over 1,000 people, and their booty was never recovered by the revenue forces. Some believe that some of the stolen goods may even still be hidden in the tombs at St Andrew's Church.

Spooky Worthing

Brighton has a plethora of ghost walks, but Worthing only has one. Brighton's may be bigger, but Worthing's is weirder! Not many tours of this nature feature Yoko Ono, chocolate, the return of Jesus and a teenage ghost bringing ice cold cups of tea. Here follows some of the sites and stories from the tour in case you want to try out the walk yourself.

Being a seaside town, we could only start our Spooky Tour at Worthing's wonderful pier. It may be a place of entertainment, amusement and jolliness, but even so it is still the site of a suicide and a reminder of the storms that brought death and destruction to Worthing in 1666, 1702 and 1705. Like Brighton, the sea end of Worthing was washed away in these storms, the waves no doubt witnessing the end of the fishing families who lived where the sea now is. Even as recently as the 1700s, Worthing had a court building near where the sea end of Worthing Pier is now and cricket was once played – imagine seeing that team return to play once more amongst the waves on a dark night! An early inn also thrived until coastal erosion led to its rebuilding higher up on the shore and even possibly a chapel. In the early 1700s, Worthing was no more than a small village surrounded on two sides by the Teville stream and the sea, which at high tide made its way to Broadwater, separating what would become the county's biggest seaside resort from its mother village. Worthing must indeed (in the days before streetlights and before the Teville Stream was paved over) have been a frightful place at high tide, the waves increasingly lapping around the dark and vulnerable early buildings and the early citizens aware the waves could easily wash their livelihoods and their lives away.

So, to commemorate Worthing's brittle relationship with the briny, we mention that the Pavilion Café (previously the Denton and the Denton Lounge) not only is the best place to watch the waves that destroyed 'lower' Worthing, but is the place to look out for spooky shenanigans. The staff today still talk of the noises made by an old woman and children in the Pavilion Theatre once the doors between the theatre and the café are chained for the night and the lights are off. Chains and padlocks on the doors between the café and theatre have mysteriously opened themselves overnight, but then we would expect no less from the theatre that once hosted a talk by some of the most evil visitors to Worthing, the British Union of Fascists. Britain's

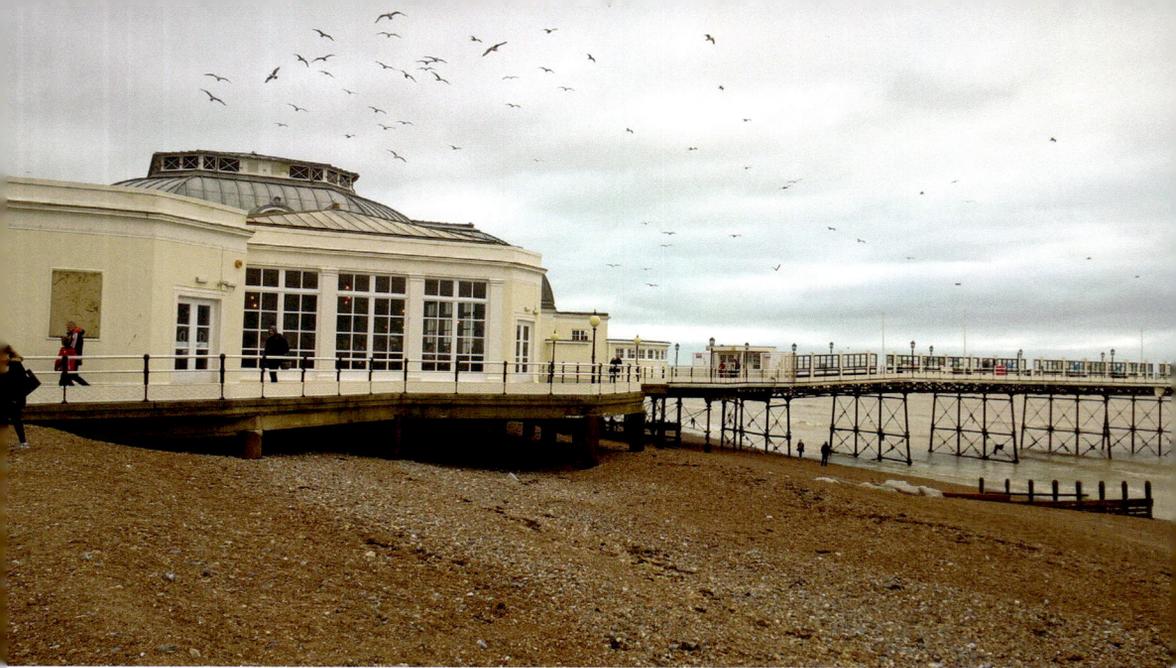

Worthing Pier's Denton Lounge/Pavilion Café/Atrium.

version of the Nazis appeared in a number of locations in Sussex, but the pier was where the BUF's leader, Oswald Mosley, heard his own peculiar noises when trying to preach his twisted views. It was the people of Worthing, banging on the pier's supports underneath to disrupt his talk.

Our Spooky Tour makes its way to a site that is a reminder of the 1893 typhoid outbreak in Worthing. May Pacy, who was eleven years old when she died in June 1893, lived in a place known as 'Pacy's Bloodhole' due to her father, George Pacy. This was not the cause of her death, though. Her father was not a contract killer, but he did run the New Street Inn and brewery where May and her many other siblings lived (it is now Liming Tex-Mex restaurant). The pub gained its gory-sounding name from George's tolerance of the fishermen of the town gutting their fish in his bar.

Water being provided in the streets during the 1893 typhoid outbreak where May Pacy died. (Courtesy of West Sussex Past Pictures, West Sussex County Library Service)

Had May stayed in her father's pub despite its gory name, she would though have survived the outbreak of enteric fever (as typhoid was also known) as the brewery had its own artisan well. She had decided, however, to visit a friend in Broadwater, near to the new water tower that gives Tower Road its name today. The tower was the source of the outbreak. Since May drank her friend's tap water, she became one of the 188 casualties it is estimated resulted from the outbreak.

Worthing must have been a scary place in the dark days of 1893 when a town lay dying. It became, to some extent, a ghost town as visitors stayed away. The town also features other horrible watery deaths, including the eleven local fishermen who died trying to save the crew of the *Lalla Rookh* ship in 1850, in the days before Worthing had its own lifeboat.

The tour sweeps around what was once the northern extremes of Worthing, talking about the library's one-time ghost, whom I reckon is now somewhere in a school (he stopped appearing about the time the library's stores became the book depository for local schools, so I reckon he hitched a ride), and the Grey Lady of the Connaught Theatre, who once was mistaken for an actor there and liked her own box at the theatre. The lobby was where she was sighted by carpet fitters in the 1980s. Should you want to go to the place even the staff feel uneasy in, then you need to go on a behind-the-scenes tour underground at the bottom of the stairs below the stage. Staff still say this can be an uncomfortable place when all is dark and that a certain presence can be felt...

Engraving of the *Lalla Rookh* in distress, November 1850. (Author's collection)

BOAT CATASTROPHE, AND THE "LALLA ROOKH" IN DISTRESS, OFF WORTHING.

Above: The Connaught Cinema, location of sightings of the 'Grey Lady'.

Left: The shops in Worthing's Montague Street, where mysterious children's images and a grey figure were seen.

Not far from the Connaught, from the top end at Ambrose Place, wander down the spooky Field Row twitten for an encounter with a former chocolate shop and its next-door neighbour, the glamourous Pandora jewellers in Montague Street. Today's shops were originally exclusive residential houses, built for large families. With upstairs being left as storerooms for many years, it has been a long time since children have been in the neglected upstairs parts of the shop. Or so it seemed. When the first CCTV cameras were installed above what is now Accessorize, they picked up children's faces appearing in the upstairs rooms above these shops, despite the public having no access to these areas and the staff not even using them. Staff would hear unusual sounds of furniture being moved at odd hours too, despite the rooms above being empty. One day, one of the staff of what is now Thorntons went up to investigate the noises and encountered a grey and nebulous being floating towards him. The spectre loomed closer to the man and simply raised a finger to his lips and said, 'Quiet!'

Today, years after first reading this story, it still sends a shiver up my spine. Why did the ghostly figure want the poor intruding shop assistant to be quiet? Was it that the children of a century ago were trying to get to sleep, or something more sinister? Were the children who once lived above Pandora kept imprisoned, and punished if they ever spoke? What would happen if children went up there again today?

We may never know the answers, but this I do know: my wife, when heavily pregnant in 2010 with our youngest, had a whole sheet of glass fall out of the window at Thorntons when she was walking past, pushing the buggy with my oldest son inside. These were the days when the shop had bigger plates of glass that took up the whole space. It came down fast, narrowly missing both her, my son and unborn son. I told her about my theories of the building afterwards and she has not visited Thorntons since with the boys. It has saved me a fortune in chocolate, though, so who says ghosts are all bad?

Following the mention of chocolate, let's finish with a nice cup of tea. The only problem is ghosts can't make a cup of nice tea, as one ghost hunter found out on his return to Worthing after the Second World War. Andrew Green, author of *Our Haunted Kingdom*, had visited his friends who lived in Wyke Avenue – they ran the bed and breakfast there in the war. They were lovely people by all accounts, and they and their eleven-year-old son helped looked after guests at the house near the Steyne.

Green remembered their hospitality when he returned in August 1951 and, after a hard day researching ghost sightings for his latest book, ended up in Worthing. He decided to pay his old friends a visit and see how they fared. He turned up, only to find the B&B run by a new couple, but as it was late and he was tired he decided to stay anyway, heading out to enjoy an evening meal.

On awakening the next morning at 8 a.m., he found a gaunt, grey-looking boy standing by his bed in an ill-fitting, bedraggled brown suit. His eyes were unusually large, he remembered, like large dark pools, and he had in his hand a teacup of tea and a saucer. The tea tasted incredibly cold and unbearably sweet, Jones recalled, having tasted a sip before falling back to sleep.

This page and opposite: Other sites on Worthing's Halloween Spooky Tour.

On heading down to breakfast, Jones chatted to other guests enjoying their meals and it turned out that they too had been visited by the teenage lad with the brown suit, the grey skin and the dark orbs for eyes. Their tea was also cold, sweet and undrinkable.

On leaving, Jones enquired to the couple whether their son was ok, on account of his skin colour and dark eyes. Their response gave him a chill that stayed with him for the rest of his life: 'What son?'

Green later discovered that the son of his friends had been killed after the war in a car accident, and at the same age as the grey boy he'd been served by.

Steyne, The

Once referred to as 'Singers' or 'Stringers', the Steyne is the central green space of Worthing seafront. It took the Scandinavian name Brighton used for its 'stoney ground' and spelled it with a 'y' instead. Bognor soon followed suit. Brighton's open

The Steyne Hotel, which can be identified by the wording at the top of the building, would be taken over by Chatsworth Hotel.

seafront space is today called 'the Old Steine' to differentiate. Worthing's Steyne was used as a recreational park where badminton was played by young Edwardian ladies. The newly built Broadwater terrace of shops and flats peaked from behind the fully grown trees on the Brighton Road. This replaced Worthing's first 'manor house', Warwick House, which was demolished in 1897 but still is remembered in the names of the streets in this part of central Worthing. Worthing's Steyne had air-raid shelters dug into it in the Second World War.

The Steyne no longer has its Steyne Hotel since the Chatsworth took over its more southerly neighbour. Should you wish to visit a sunnier Steyne Hotel, then a flight to Manly in Sydney, Australia, is where you can enjoy such a building, built originally in 1859 and with the current hotel building dating from 1923. The choice of name may well be partly explained by its builder, Henry Gilbert Smith, being linked with Sussex – he died in Brighton in 1886 and even originally referred to Manly as 'Brighton'. But it doesn't explain his choice of the Worthing/Bognor spelling of 'Steyne' as opposed to Brighton's 'Steine'.

The Steyne in Worthing today. No. 2 is now one of the offices at the north end near Whibleys the jewellers, but in the 1930s was the Picardo School of Dancing.

Town Hall (New)

Before Worthing's first Town Hall was built in 1835, town councillors (first called commissioners) met upstairs in the Nelson Inn on Chapel Street, then in the Royal George in Worthing's lost Market Street. Worthing's first Town Hall was completed by 1835. It was funded by a public subscription that was meant to fund a clock tower, which did arrive, but on the top of the Town Hall. By the 1930s, however, it was too small for civic business and was no longer seen to reflect the scale of the growing town of Worthing. It was left to decline and was sadly demolished in 1966, replaced by a set of steps to the 1970s Guildbourne Centre and, ironically, a rather spindly clock tower in a flower bed.

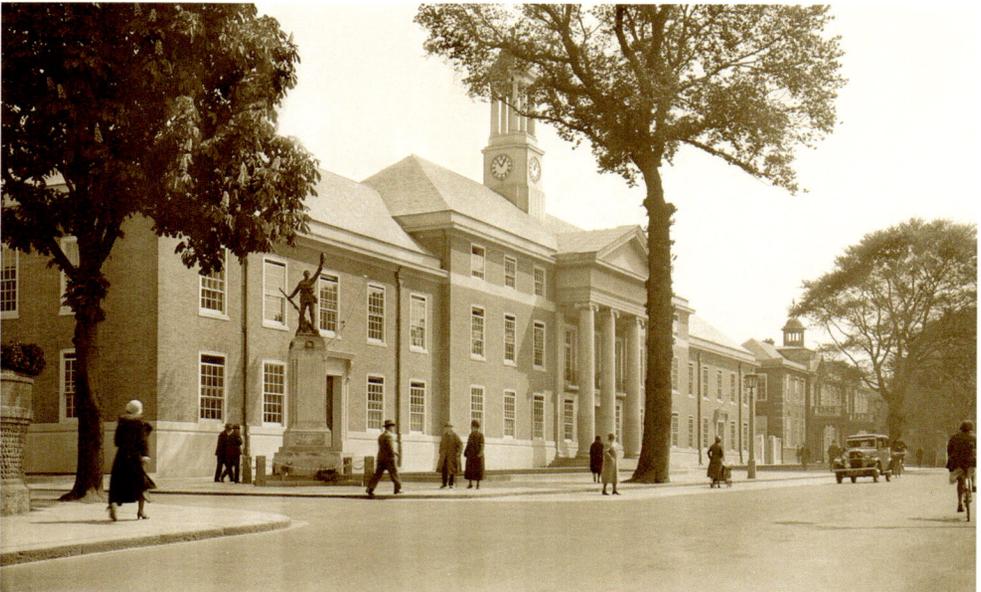

Worthing's New Town Hall, built in 1933. (Courtesy of West Sussex Past Pictures, West Sussex County Library Service)

Worthing's new Town Hall in 1933 had no fears of being seen as too small – quite the opposite, in fact. In a time of economic depression, locals balked at the scale of the building and its design. The design doesn't look like a typical 1930s building, with its faux-Georgian appearance. It is a marvellous building inside and out, with the main council chamber and mayor's parlour worth a visit whenever a tour is arranged. The town's Latin motto, which translates as 'from the land, fullness, and from the sea, health' proudly displays across its classical front, with a pediment and clock tower giving it the look of the Town Hall that Doc Brown hangs off in *Back to the Future*.

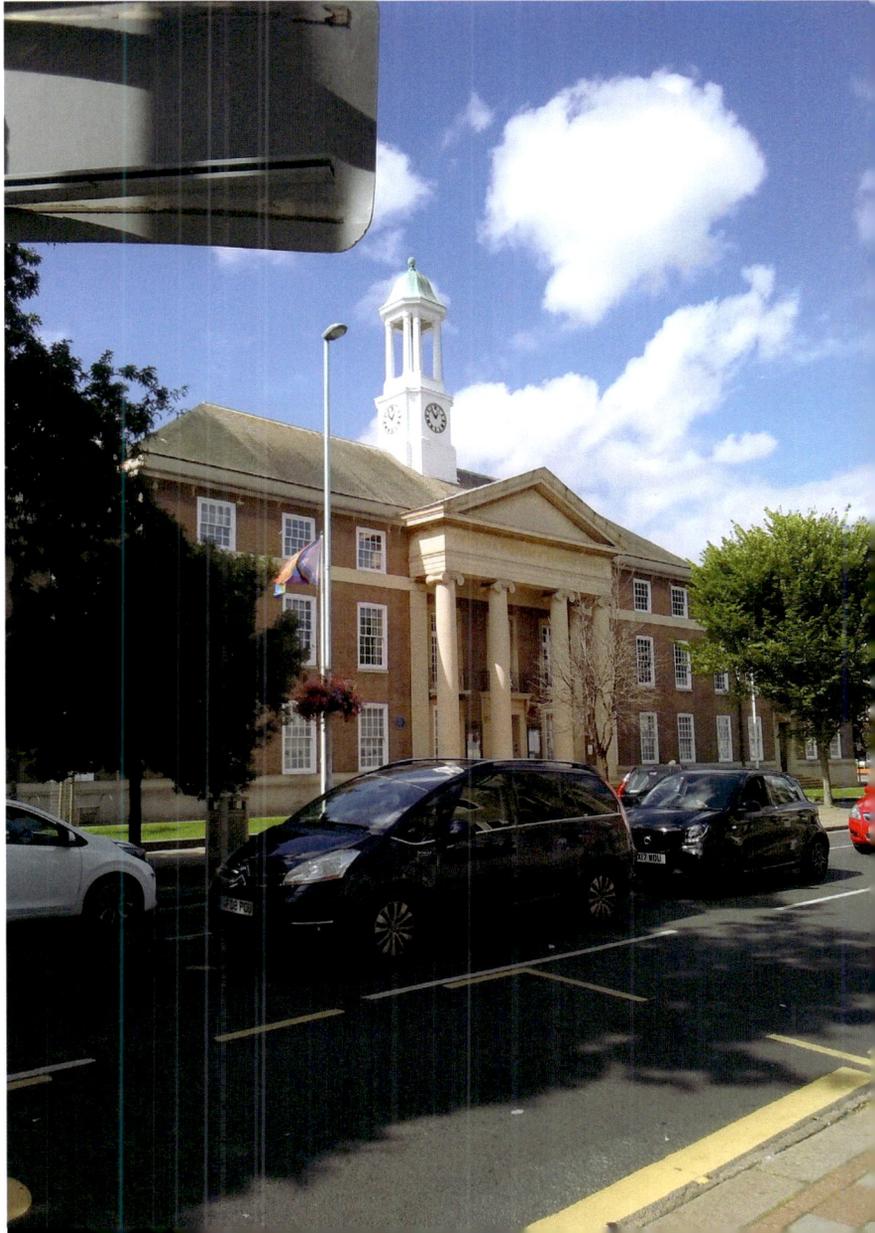

Worthing's New Town Hall today. Criticised at the time of building for its expensive construction costs during the Depression, it has aged well and today provides a show of civic pride to those entering the town centre.

Unusual School Features

Some Worthing schools have contained some unusual features over the years. Worthing College, in its second incarnation at what became known as Beachfield on Brighton Road, just east of Splashpoint today, contained not only a chemical laboratory but also a private skating rink, according to Antony Edmonds in *Lost Buildings of Worthing*. Durrington High School to the west of the town can go one step further with its interior features, however. The building has drainpipes that rain runs down during rainstorms. This is because the more recent 1990s buildings were built over the original 1950s classrooms, drainpipes and all. The Technical School that was once part of its campus was even quirkier than the surviving buildings today. The school had a 'terrible tower', which wobbled when the wild blew hard, and outside of the building a line across the playing fields marked how the boys and girls had to stay apart.

V

Victoria, Queen

Worthing's links with the country's second-longest-reigning monarch have diminished over the decades, but they can still be found. Victoria Park is so named as it opened in 1901, the year of the monarch's death. But should you wish to toast her reign in the town's pub that was named in her honour, you'll struggle; the Victoria Arms hasn't served drinks since 1984. Its former location at No. 103 Montague Street is retail premises today.

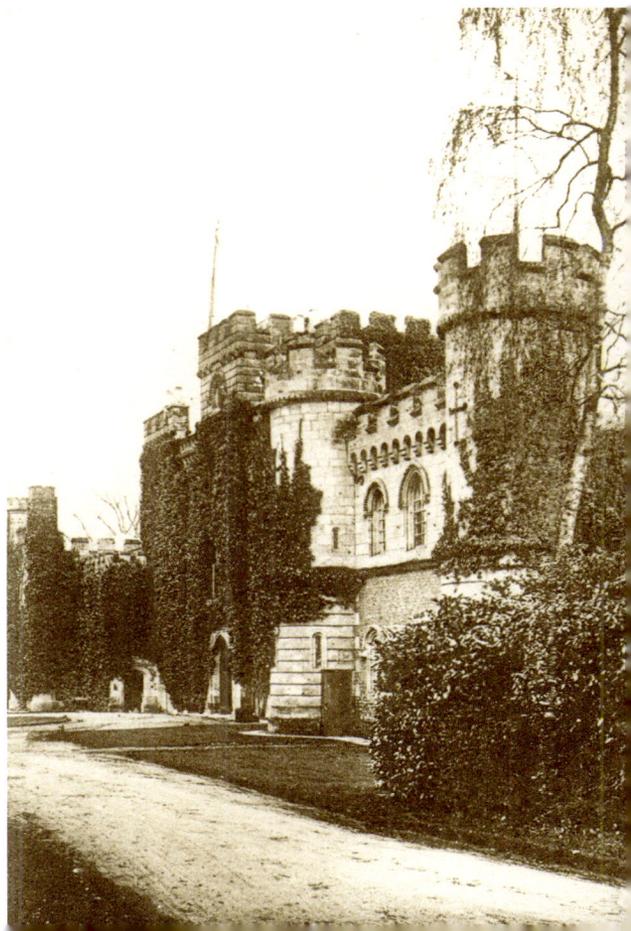

Castle Goring, part of Victoria's route through Sussex in 1842. (Courtesy of West Sussex Past Pictures, West Sussex County Library Service)

Links with the queen can be found in Broadwater Cemetery. Caroline Heath Barrett, who was appointed by Queen Victoria as her private reader, is buried there. Caroline's employer passed through Worthing twice, the first time in 1842 while en route to Portsmouth. A book celebrating the journey explains that: 'About half-past eight o'clock the ... town band played the national anthem on the platform fronting the Marine Hotel (today site of the Cow and Shed) and the royal travellers were escorted by a loyal cavalcade as far as Broadwater.' Even as the procession left the town the celebrations continued: 'From the towers of Castle Goring were displayed a variety of flags ... and a royal salute was fired.'

Six years later, Worthing was a stopping point as Victoria and her entourage headed for a stay at Arundel Castle. This time the Marine Hotel was used to change horses and a large crowd assembled to cheer the royal couple, who did not leave their carriage.

Worthing is also linked to Victoria's final days. Banting's firm of undertakers was Britain's most famous, and buried royals from George III to Edward VII, along with Thomas Banting Jr. He was son of the founder and moved to the town, becoming something of a celebrity and donating money for a convalescent home.

Warwick Street, Battle of

On 9 October 1934, Oswald Mosley spoke to a large audience at the Pavilion in Worthing. The fighting between locals and the BUF that followed is known as the 'Battle of Warwick Street'. Mosley's visit, says Chris Hare in *Worthing: A History*, was in 'recognition of the hard work being done in Worthing for the movement'. He continues: 'The day started badly [for the fascists], posters all over Worthing saying "Mosley Speaks" had been doctored to say "Gasbag Mosley speaks tripe".' This had been the work of Roy Nicholls, leader of the Young Socialists in Worthing at this time. Mosley's entrance to Worthing in an armoured car, followed by an ambulance and Black Shirts equipped with truncheons, suggested he knew there would be trouble. He was right.

As Mosley got ready to address a carefully arranged and vetted audience inside the Pavilion that evening, an angry mob gathered outside. Mosley made a dramatic entrance to the stage, with spotlights shining upon his black uniform and sparkling metal belt. The total effect was slightly ruined however by Mosley having to ask for the front spotlight to be turned off as it was dazzling him. Protesters then made the fascist rally more farcical by banging on the doors and even the metal supports of the pier below the theatre. A small band of intruders further disrupted the meeting by letting off squibs (explosives) and had to be ejected by 'hefty East End bouncers'.

Mosley continued with an anti-Semitic tirade, telling the assembled audience that Britain's enemies would have to be deported. After the rally Mosley and Joyce left the Pavilion to the sound of heckles and threats (including to throw Mosley in the sea). They were protected by a large body of Black Shirts and crossed over the road to Barnes' Café in the Arcade. Clark & Taylor report in *Worthing & WW2* that the crowd also sang, 'Poor old Mosley's got the wind up!' suggesting he was scared. He was quite right to be scared, as stones and rotten vegetables soon began crashing through the windows of the café, and boys were observed firing peashooters. While this was happening a group of men got onto the roof of the arcade and dislodged a large piece of masonry, which plummeted through the arcade, landing just feet away from the fascist leader.

The fascists then seemed to make a run for it, according to Michael Payne in *Storm Tide*, as a plan by Joyce and Mosley to create a diversionary tactic to get the anti-fascists away from Mosley. Led by Joyce, they ran through the Royal Arcade and up

South Street, probably trying to get to the Black Shirts' favoured pub, the Fountain (The Slug and Lettuce today), or their headquarters in Warwick Street. The opponents ran after them. As the fascists reached the western end of Warwick Street, they found it blocked by hundreds of opponents, so, after first fighting on the corner of South Street and Warwick Street, they tried to get to their HQ by going north through Market Street. There were many opponents here too, and so a second fight broke out in Market Street (today demolished and replaced by the Guildbourne Centre). Mosley now heard of the problems faced by Joyce and his supporters, so left the café and proceeded to get to Market Street via Bedford Row, Warwick Street and the High Street. Here they charged the rear of the force, assaulting Joyce's men. With Mosley at the lead, this rearguard action (christened 'the Charge of the Black Brigade' by the national press) was successful and the angry anti-fascist crowd thinned. Mosley could now return to the throng in Warwick Street and try to get the opposing mob away from his HQ in Warwick Street. Around 400 opponents were still facing the Black Shirts here, Payne estimates. The fighting turned very nasty once more, dubbed by Payne as a 'seething, howling mass of struggling bodies'. The Black Shirts seemed to be getting the upper hand, even though Mosley by this time had received two punches to his face. Only the arrival of a larger number of Sussex police stopped the fight. Several Black Shirts were arrested and taken away to loud cheers from the crowd.

On 5 November 1934 fighting between the BUF and their opponents again broke out in Worthing. On the days leading up to Bonfire Night, several boys and men known to be hostile to the BUF had been waylaid at night and beaten up. Bonfire Night was to see several cases of retaliation. At least one BUF member was thrown in the sea. Cars were scrutinised to see if BUF members were inside or not before being allowed to pass. Nearly 1,000 people gathered outside the Beach Hotel after rumours that fascist leaders were inside. Squibs and crackers were thrown up at the windows and in retaliation buckets of water were tipped over the mass of people below. The police once again intervened to stop matters getting worse.

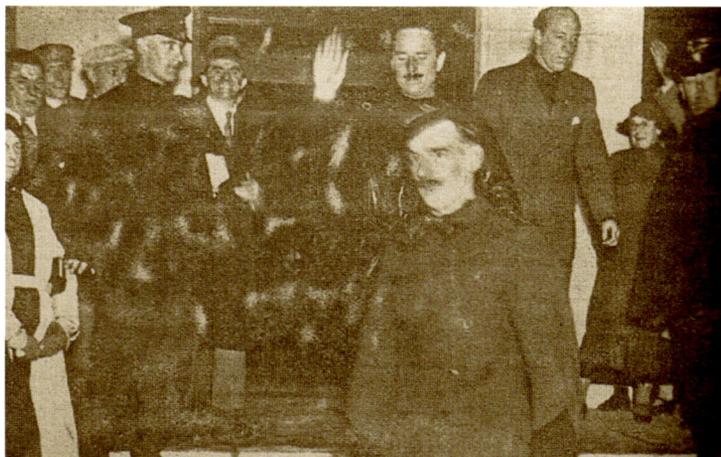

Mosley leaving the Assembly Hall following a meeting. (Courtesy of National World)

The BUF lost most of its supporters from this time, as Hitler's intentions regarding a new war became increasingly clearer and it was hard for people to support an institution with links to Italian fascism after their cruel and barbaric invasion of Abyssinia. However Mosley still managed to gain an audience of over 900 when he addressed the fascists at the Town Hall. This meeting passed off mostly uneventfully, except for heckling.

Mosley addressed a further meeting in Worthing in 1935, as he did again for the last time in 1938. On both occasions police had to check houses in the town for weapons they suspected would be used at the events. His last public speech in Worthing was at the Town Hall on 16 November. He spoke to a capacity crowd and advocated resettlement of Jews to uninhabited parts of the world. This time there was little disruption despite over 200 protesters having gathered outside, as the police presence from the start kept things peaceful. Staggeringly, as Chris Hare notes, at this speech 'Mosley claimed that he had received just as much persecution in England as the Jews had in Germany.'

Mosley was interred during the Second World War, but resumed his racist views against black immigrants to Britain as the country entered the Windrush era. He died in 1980 after suffering from Parkinson's disease.

Despite being host to a series of fascist rallies, the people of Worthing consistently did not support them, and protested in large numbers too. Locals also demonstrated that the Black Shirts could not march in Worthing en masse – two years before the much more famous Battle of Cable Street. The anti-fascist battle cry of Cable Street

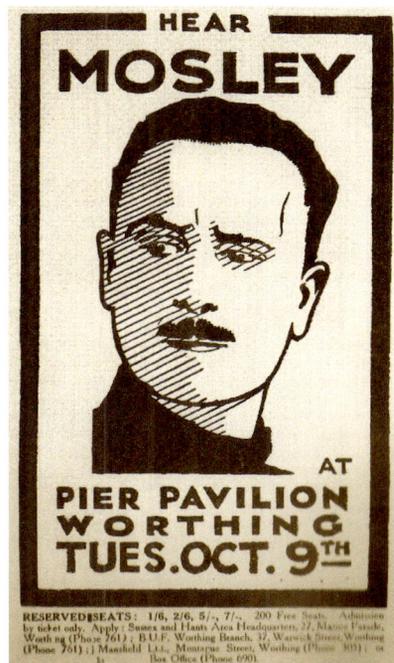

A poster advertising Mosley's appearance in Worthing.

'They shall not pass!' also held true in Worthing, and perhaps inspired those elsewhere to stand up to the Far Right.

West Tarring

The 'West' part of West Tarring's name was added to distinguish it from Tarring Neville, near Newhaven, East Sussex. It is far older than Worthing, the first record of its existence being when King Athelstan (894–939) granted it to Canterbury Cathedral. Its links with Canterbury remained for several centuries. The land was owned by the Archbishops of Canterbury, including Thomas Becket. Local legend tells Becket visiting the village and being linked to the Archbishop's Palace, although no evidence of either has ever come to light and the palace's far later construction makes the story look improbable.

West Tarring's most famous resident was MP, writer and historian John Selden (1584–1654) from nearby Salvington. Selden is seen as the nation's most prominent historian of his time. He was born in Lacie's Cottage in 1584. The building boasted a thatched roof, stone walls and timber framing, but was demolished in 1956 following a fire caused by an electrical fault. Should you wish to celebrate the man's life, you can enjoy a drink in the John Selden pub in Salvington and see a memorial to him at St Andrew's in Tarring.

Ink drawing of Selden's Cottage, Salvington, 1921. The artist is believed to be F. Sutton. (Courtesy of West Sussex Past Pictures, West Sussex County Library Service)

Wilde, Oscar

So grateful was Oscar Wilde for the time during the summer of 1894 that he spent in what is today West Sussex's largest town, that he named his main character Jack Worthing in his greatest work, *The Importance of Being Earnest*. Wilde also used the owners of St Mary's House in nearby Bramber – fellow Irishman the Hon. Algernon Bourke and his beautiful wife Gwendolen – as inspiration for the other main characters in the play. Wilde managed to complete the work in three weeks in Worthing, despite distractions from his young lover, Bosie, and in between time devoted to playing with his boys on the beach and sailing. Worthing was dragged into the national press the following year when his court case against Bosie's father, who was accusing him of homosexuality (then illegal), made the news. Worthing's local press, which had covered Wilde's stay so fully in 1894, this time tactfully mentioned nothing of the writer.

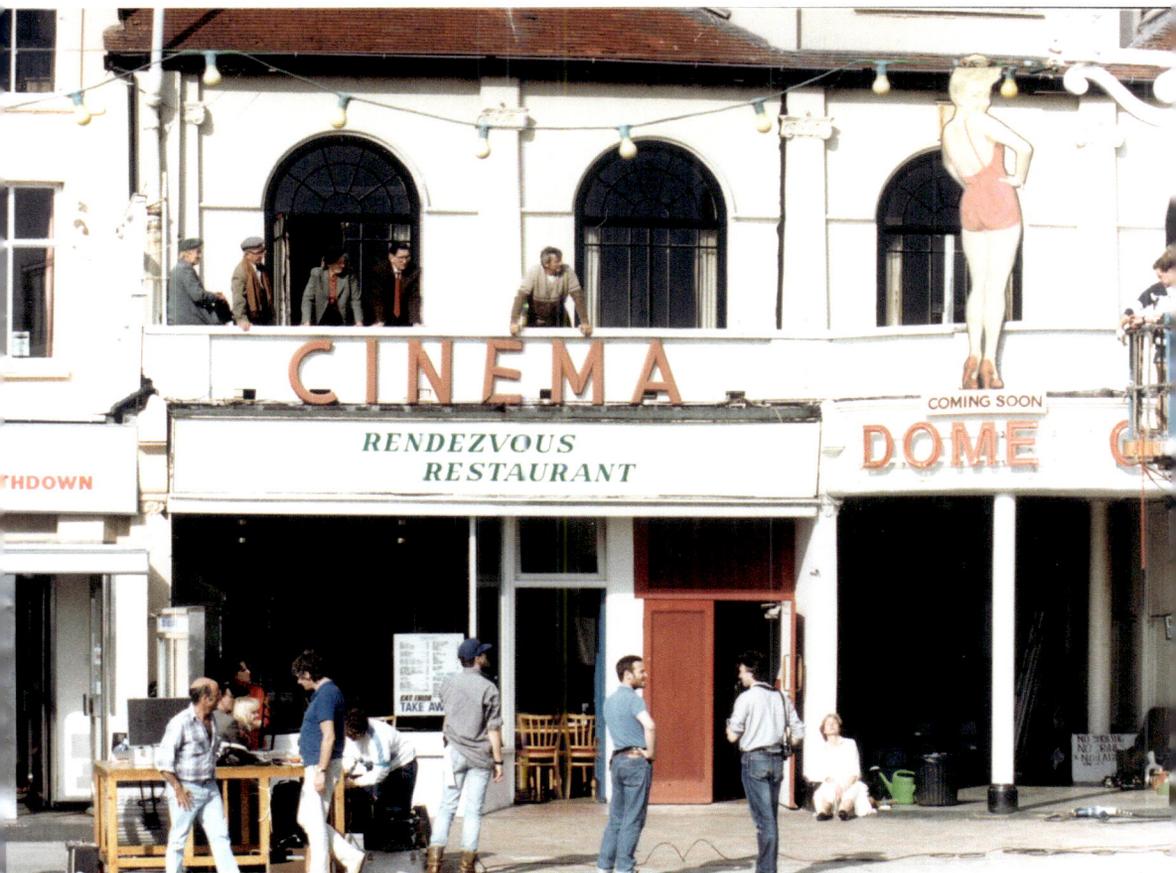

A scene from *Wish You Were Here* outside the Dome. (Courtesy of West Sussex Past Pictures, West Sussex County Library Service)

X-rated

Worthing was one of twenty-eight local authorities that chose to ban the public performance of Monty Python's *Life of Brian* on its release in 1979, giving it an 'X' rating. Concerns at the time included its swearing and nudity. In 2019 it was downgraded to a 12A rating for 'infrequent strong language, moderate sex references, nudity [and] comic violence' not to mention a very naughty boy.

Y

Yoko Ono

The scariest ever noise in a neighbourhood came from a Victorian church surrounded by an eerie graveyard in the centre of Worthing. Back in 2015, Christ Church in Grafton Road was the source of an ear-piercing, shrieking cacophony. The noise that ruminated from the church made babies cry, grown men weep and people hold their ears in pain. Thankfully it was just Yoko Ono singing at a concert at the church and she soon stopped.

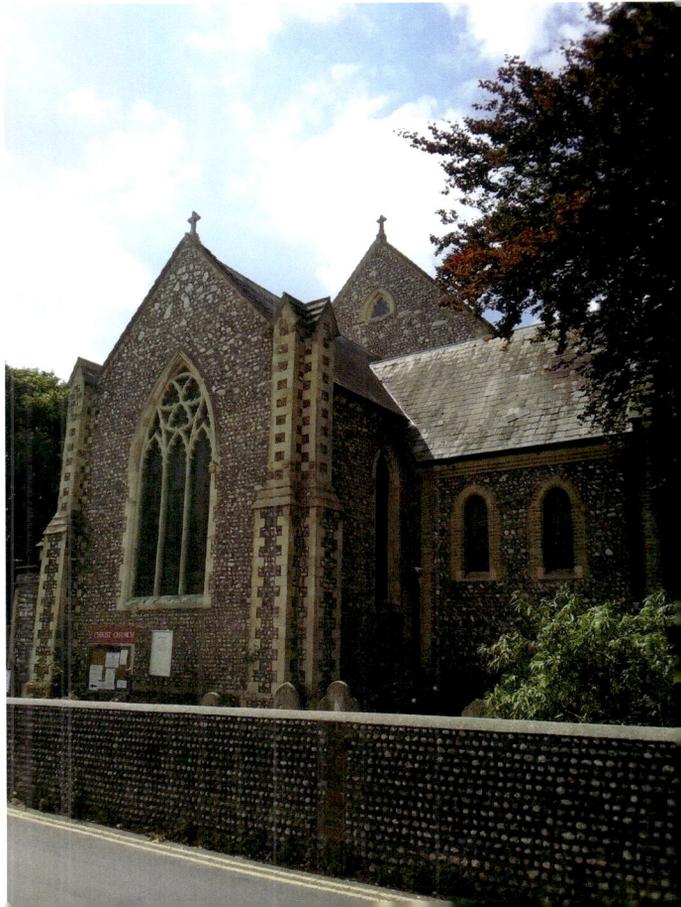

Christ Church, Worthing, where visitors were treated to the pleasant sounds of Yoko Ono.

Youth, Hitler

Worthing High School, supported by local peace groups, was the host of a delegation of schoolboys from Soest, Germany, in 1936. It was hoped that a youthful exchange of sporting prowess would signal to both countries that rivalry between both could be played out in sport. The contingent of seventeen boys came to Worthing to perform a play on Thursday 26 March, but they were all in the Hitler Youth (though to be fair it was the law that you had to be in Germany at this time if over the age of ten). They put on a show of gymnastics that amazed R. G. Martin, the headmaster, who compared their physical prowess and stature favourably over the local Worthing boys. They apparently enjoyed performing their routines before getting a tour of the council chamber and assembly hall, an afternoon of music and strolling on the beach, before being the guests of the mayor for tea. That evening they performed their play to a warm reception, and in the following days hiked the 9 miles up to Chanctonbury Ring before returning home.

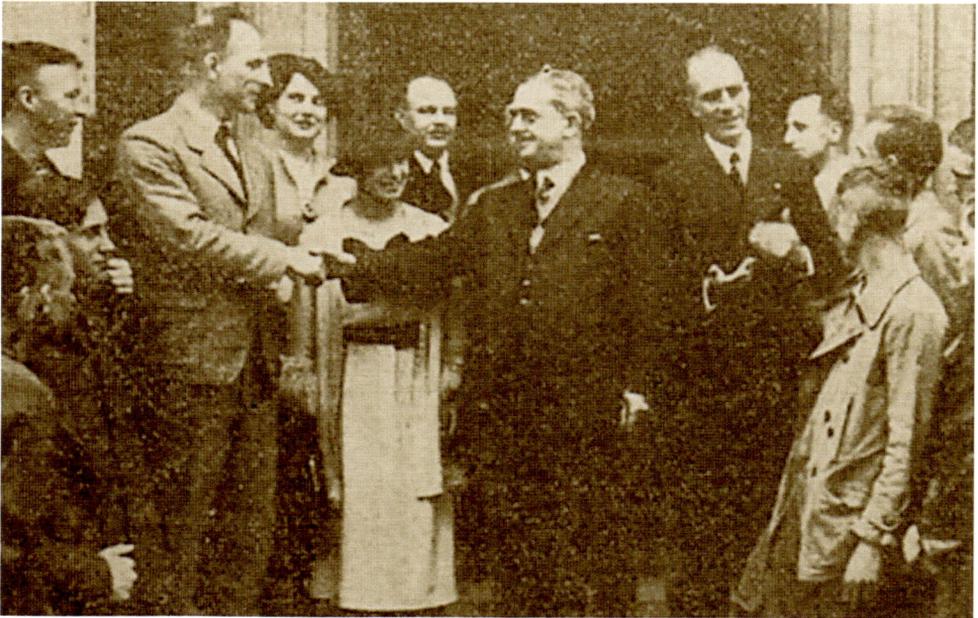

The mayor and R. G. Martin, headmaster of the school and seen on the far right, with visiting German schoolboys, 1936. (Courtesy of National World)

Z

Zoo

Brighton's aquarium (today the Sea Life Centre) was home to performing dolphins between 1968 and 1990, until the popular mood against their captivity grew and they were forced to find a new home for them. Worthing has never had a zoo, but the homeless dolphins meant that the town briefly gained an aquatic zoo of sorts as one as the dolphins was temporarily rehomed to Worthing's Lido pool before being set

The Lido *c.* 1957, when its swimming pool was used by people, not dolphins. (Courtesy of West Sussex Past Pictures, West Sussex County Library Service)

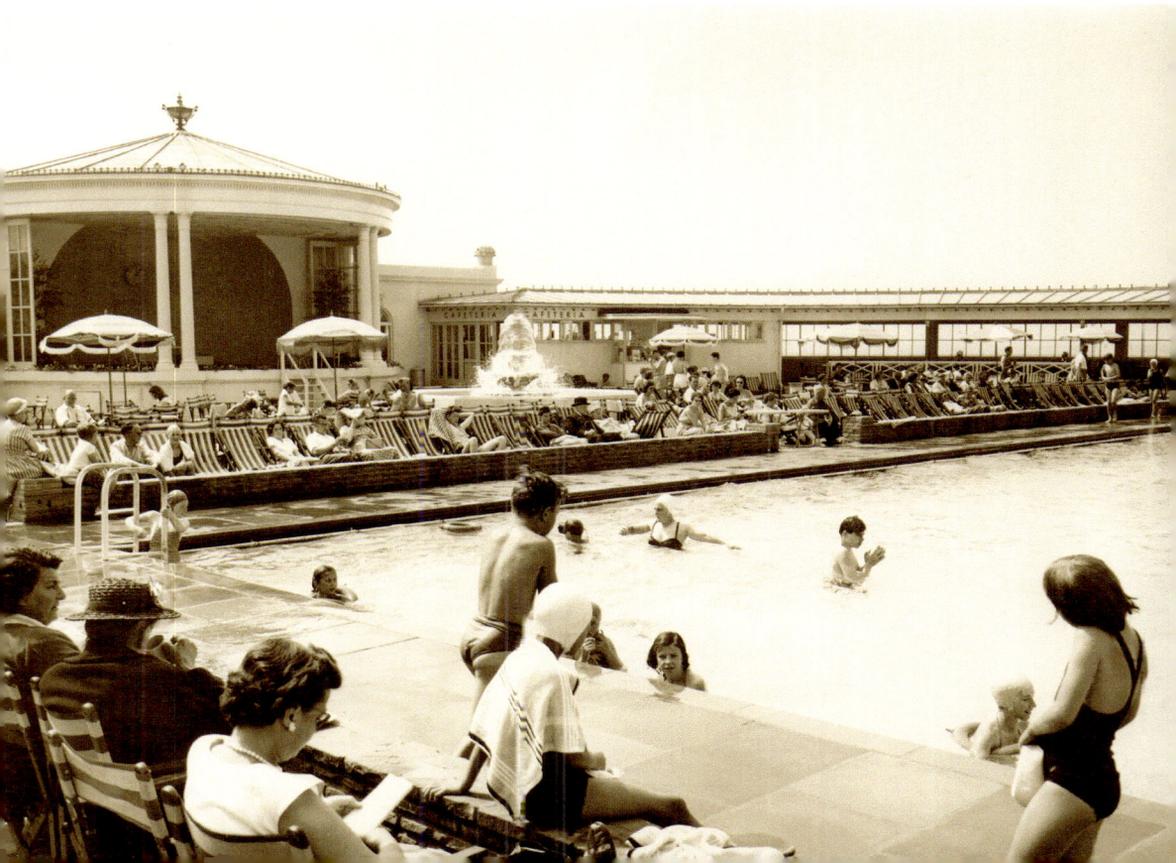

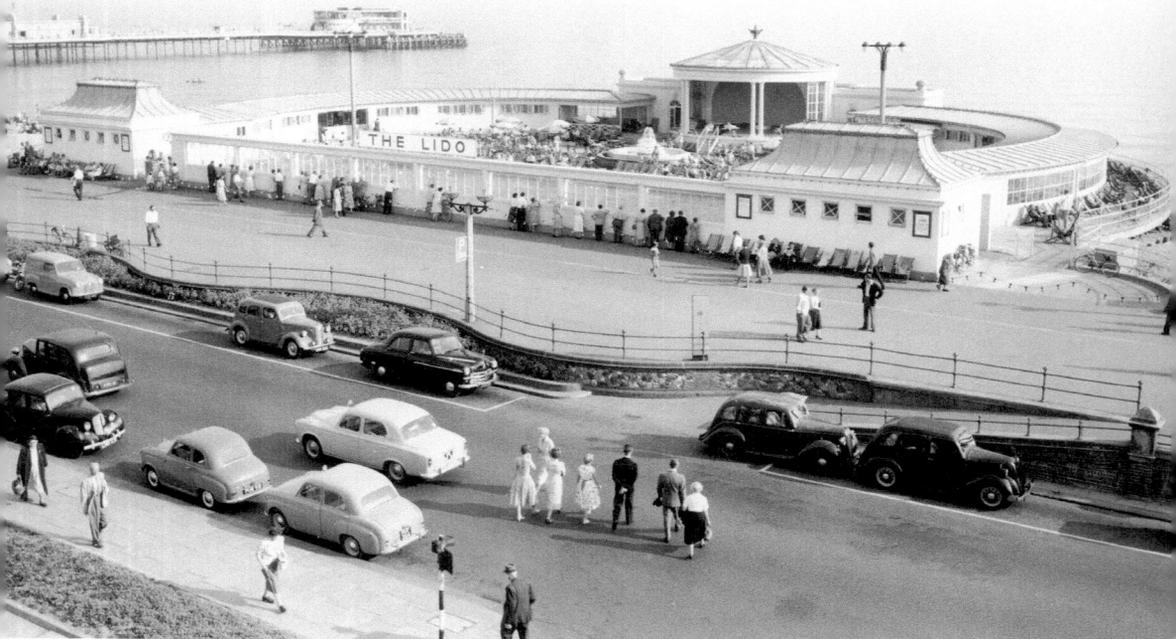

The Lido, pier and beach, *c.* 1957. Worthing at its best, and not too dissimilar from today. (Courtesy of West Sussex Past Pictures, West Sussex County Library Service)

free in 1991. No record of what happened to them post-release exists. We hope that they survived for many years, swimming in the freedom of the seas and happy that their last memory of captivity was enjoyment of the wonderful place that is Worthing.

And now reader, like the Aquarium's former dolphins, you too are free. And I firmly suggest that, unlike the dolphins, you go and explore this great town of Worthing, be it for the first time or to look at its twittens and townscape anew. Why should you do this? Well, in the words of Martin Clunes' *Men Behaving Badly* character Gary, because Worthing is still somewhere … a bit special.

If you would like a tour guide to accompany you for an 'A–Z of Worthing' walking or motorised tour, please call All-Inclusive History on 07504 863867 or email info@ allinclusivehistory.org. Other tours are available, including 'Saucy Sussex', 'Silly Sussex' and, most popular of all, 'Spooky Worthing'. All-Inclusive History also run a range of Worthing and Brighton-based talks for businesses, organisations and schools.

Acknowledgements

I am most grateful to Angeline Wilcox, who originally commissioned this book, and to my current editor, Nick Grant, for his advice and support. Thank you also to Jenny Bennett and Becky Cadenhead. My thanks to Antony Edmonds for being supportive of the book from the start and for his kind offers of help, which I sadly wasn't able to take up. He also provided research on Yolande Jackson and Paul Robeson's time in Worthing. My thanks also to the West Sussex Record Office for allowing use of West Sussex Past images. Please go to westsussexpast.org to explore their many fantastic pictures. Amy Perry is now West Sussex Past's point of contact. On the subject of images, thanks also to Phil Hewitt of National World for permission to use images too, as well as the very wonderful Simon Nye.

As always, my heartfelt thanks go to my wonderful family, Laura, Seth and Eddie, for their patience, support and encouragement and for all the happy memories from our early days as a family of four together in Worthing. It is still my favourite place in the world for loaded fries on the beach.

Lastly, apologies to Yoko Ono, who, quite frankly, deserves better.

About the Author

Kevin Newman is a Sussex author, teacher, tour guide and historic events organiser, and this is his tenth book for Amberley. He contributes history supplements and articles to the *Argus* newspaper in Sussex, the *Sussex Newspaper* group, and to the various *Sussex Pages* magazines as well as to *Sussex Life* and *Exclusively British* magazine. Believe it or not, he is actually a fan of Yoko Ono's work.

Other Books by the Author

Brighton and Hove in 50 Buildings
Secret Brighton
Lewes Pubs
50 Gems of Sussex
Historic England: Sussex
Historic England: Brighton and Hove
A–Z of Brighton
Celebrating Brighton and Hove
Pond Puddings and Sussex Smokies: Sussex's Food and Drink
Clock Towers of England